THE LEGACY OF FLIGHT

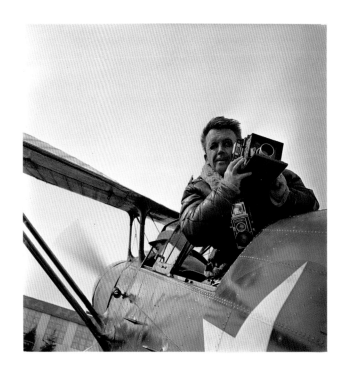

THE LEGACY OF FLIGHT

IMAGES FROM THE ARCHIVES OF THE SMITHSONIAN NATIONAL AIR AND SPACE MUSEUM

DAVID ROMANOWSKI AND MELISSA A. N. KEISER

BUNKER HILL PUBLISHING

in association with the Smithsonian National Air and Space Museum

www.bunkerhillpublishing.com

First published in 2010 by Bunker Hill Publishing Inc.
285 River Road, Piermont, NH 03779 USA

10 9 8 7 6 5 4 3 2 1

ISBN 978-1-59373-083-3

Library of Congress Control Number: 2009942070

Designed by Peter Holm, Sterling Hill Productions

Printed in China

FRONTISPEICE: Photographer Hans Groenhoff poses in the rear cockpit of a Douglas
O-46A carrying the tools of his trade: a Speed Graphic and an Ikoflex twin lens
reflex.

DEDICATION

DAVID

For Sophie and Edmond, my guardian angels

MELISSA

For Richard and Amanda, who make it all worthwhile

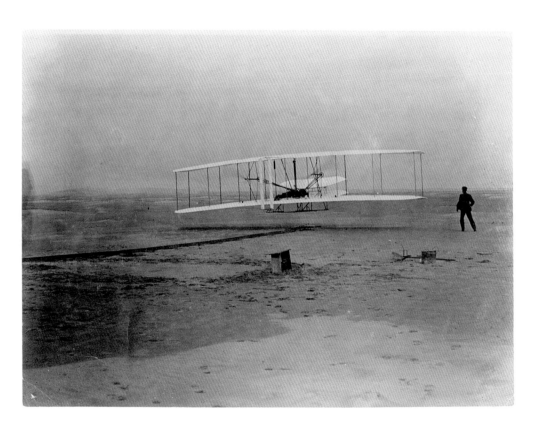

INTRODUCTION

A camera was there…unobtrusive, a silent witness. Atop a tripod on the wind-swept sands of Kitty Hawk, North Carolina, a Korona-V camera recorded for posterity a momentous event on December 17, 1903: the first successful flight of the Wright brothers. One ephemeral moment caught in the lens of the Korona-V shows Orville Wright at the controls of the Flyer as it ascends on a historic 12-second, 120-foot powered flight. That same iconic image captured Wilbur Wright running alongside the starboard wing of the Flyer as it leapt into the air. Between 1898 and 1911, in fact, the Wright brothers used cameras to document their myriad flight experiments. These extraordinary images, consisting of 303 glass plates, came to the Library of Congress in 1949, an inestimable legacy from the estate of Orville Wright. The camera—itself a radical new technology at the turn of the 20th century—gave witness to the birth of the air age.

The synergy of photography and aviation (and later, space flight technology) has shaped our sense of modernity. Photography itself predated the advent of the first heavier-than-air flying machine, emerging as a new technical marvel in the 19th century through the pioneering work of L. J. M. Daguerre, Joseph N. Niepce, William Fox Talbot, Hamilton Smith, Richard Mattox, George Eastman, and others. Like the airplane, the camera evolved rapidly as a technology, reaching a new level of sophistication just on the eve of the historic flight of the Wrights. George Eastman, in particular, sparked a revolution in photography with his invention of the Kodak camera. A small box

camera, the Kodak was self-contained with 100 exposures of film on a roll. For the non-professional, the Eastman design proved to be simple, inexpensive, and—most important—highly portable. Suddenly and irreversibly, photography acquired a formidable populist dimension.

As the air age unfolded, the ubiquitous camera offered an effective way to showcase the rapid advances in this new aeronautical world. Photography recorded how flying machines underwent constant refinement in design and performance with the relentless quest to fly "faster, higher, and farther." The shift from the wood and fabric craft of the Wright era to modern streamlined jets took place in a relatively short timeframe and the camera documented the transformation. In war, the camera went aloft to serve as an effective tool for reconnaissance. Color photography arose in the 1930s. With the space age, various types of cameras became an integral part of space exploration, most notably the close-up images of the lunar surface and the memorable "Earthrise" photographs taken by the Apollo 8 astronauts with a Hasselblad camera while orbiting the Moon. No less spectacular, robotic space missions have used automated cameras to photograph the surface of Mars and more distant planets in the solar system. The Hubble Space Telescope, launched in 1990, has revealed stunning views of celestial bodies billions of light-years away. Indeed, the gaze of the camera profoundly altered human perceptions of time, distance, and space.

The Legacy of Flight: Images from the Archives of the Smithsonian National Air and Space Museum offers the reader a stunning array of historical images to express the myriad forms and impact of aerospace technology. These images are drawn from the rich holdings of the National Air and Space Museum Archives. The book owes its genesis to a popular photo presentation prepared by Melissa Keiser, chief photo

archivist, for the opening of the Museum's Steven F. Udvar-Hazy Center on December 15, 2003. This event coincided with the Centennial of Flight, an occasion for global celebration and historical reflection on the impact of aerospace technology. Accordingly, Keiser faced the daunting challenge of putting together a visual representation of this extraordinary sphere of human activity. In the end, she chose 132 images for her presentation. Her criteria for selection, at its core, was highly personal, even impressionistic, based on her unrivaled familiarity with the Museum's archival holdings. At the outset, she rejected any notion of fashioning a comprehensive history. That task would be daunting, given the limits of photography and format for the presentation. Moreover, she did not wish to be defined by any narrow checklist of famous names, key events, or aircraft types: the final selection would offer snapshots or ephemeral moments caught by the camera. Some photographs selected were familiar; others less so, or even unknown except to air enthusiasts. Both civilian and military spheres of flying were represented. Pilots offered a logical and compelling theme, but the final selection, by design, aimed to include mechanics and other non-flying personnel, even children. The scenes captured might be epic or ordinary, with each snapshot from the past capable of telling a story. Once completed, the slide show made a powerful impact on all who viewed it at the Udvar-Hazy Center's opening in 2003.

The response to Melissa Keiser's slides was enthusiastic. The idea of transforming the content of this PowerPoint presentation into a book quickly followed. To achieve this end, Keiser sought out writer-editor David Romanowski of the Museum's Exhibits Design office to write the narrative text for the proposed book. His task was to add words to images in order to put the original slides one-by-one into a

proper focus. There was no need for Romanowski to write an overarching narrative since each photograph or illustration stood alone. Instead, he wrote individual essays that told stories evoked in the images. As a collaborator, he aimed to write outside the narrow confines of a conventional caption. Each of the 132 images, depending on the focus, presented its own challenge—and the various dramatic events and personalities required careful research and reflection. Such an exercise mandated a careful consideration of the human dimension, no matter how hidden or elusive in nature. Brevity also became the governing principle. In the end, the textual component for the book acquired a fresh and creative formulation.

The Legacy of Flight: Images from the Archives of the Smithsonian National Air and Space Museum offers the reader an engaging avenue to revisit aerospace history, in all its diversity, now entering its second century.

VON HARDESTY, Curator
Aeronautics Division
National Air and Space Museum

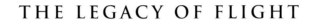

THE LEGACY OF FLIGHT

"A Caution to Aeronauts." The tale of Daedalus and Icarus—the determined but careful aeronautical designer and test pilot and his careless protégé—has for ages served to warn those seeking to "push the envelope." To escape imprisonment on Crete, Daedalus fashioned wings from feathers and wax for himself and his son. He warned young Icarus not to fly too low to the water or too near the sun, lest his wings either get wet or melt, but Icarus, as sons are wont to do, failed to mind.

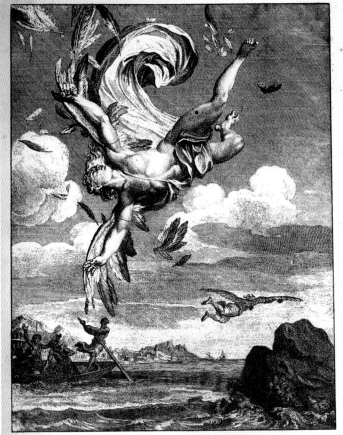

THE FALL OF ICARUS.

Photo-zincographed at the Ordnance Survey Office Southampton under the superintendence of Capt.n H. Blaton Armn R.E. 6d. Sir H. James R.E. F.R.S. &c Director.

Mr. Steiner's wild ride. Aeronaut John Steiner could hardly have chosen a worse day to attempt the first balloon crossing of Lake Erie to Canada. Winds howled across the water and a storm threatened, but he lifted off anyway from Erie, Pennsylvania, on June 18, 1857. He soon regretted it.

"Oh! What a scene was transpiring around me!" Steiner recalled, as lightning flashed and thunder crashed while he sailed through the turbulent clouds. He had nearly reached the Canadian shore when the wind shifted and swept him down the lake toward Buffalo, more than 60 miles away. With dusk approaching, Steiner decided to descend and head for the steamship *Mary Stewart*. Soon his craft was bounding across the waves, "rushing down the Lake at railroad speed." A boat crew dispatched from the steamer managed to snag his anchor line, then found themselves clipping along behind the balloon as though harpooned to an angry sperm whale. Steiner finally bailed out and was fished from the lake. His balloon blew far off into the Canadian wilds without him.

This ambrotype image, taken that day by an unknown photographer just before Steiner's flight, is historic for another reason: it is the earliest known photograph of an aviation event in the United States.

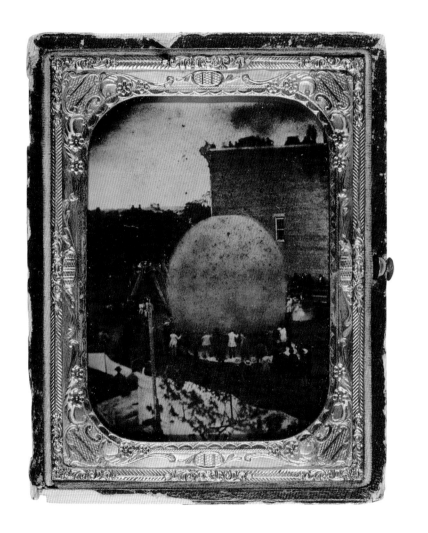

"The Flying Man" of Lichterfelde. Newspaper and magazine photographs of Otto Lilienthal gliding down hillsides near Berlin in the 1890s stirred excitement around the world. Lilienthal made nearly 2,000 flights, some extending almost 1,000 feet and lasting 12 to 15 seconds. His success stemmed from more than 20 years of careful research. He compiled the best body of aeronautical data in existence and established that a curved wing surface created more lift than a flat one.

Lilienthal built and flew many different gliders, including this biplane design. His single-wing gliders, which looked and operated much like modern hang gliders, performed best. But control remained precarious, as a strong gust of wind on August 9, 1896, tragically proved. Lilienthal's glider nosed up, stalled, and plummeted 50 feet to the ground. The fall broke his spine, and he died the next day.

Lilienthal's death inspired two keenly interested followers in Dayton, Ohio, to pursue flight research. Wilbur and Orville Wright obtained Lilienthal's aeronautical data and adopted his methodical approach to experimentation. Wilbur Wright later wrote that Lilienthal "was without question the greatest of the precursors, and the world owes to him a great debt."

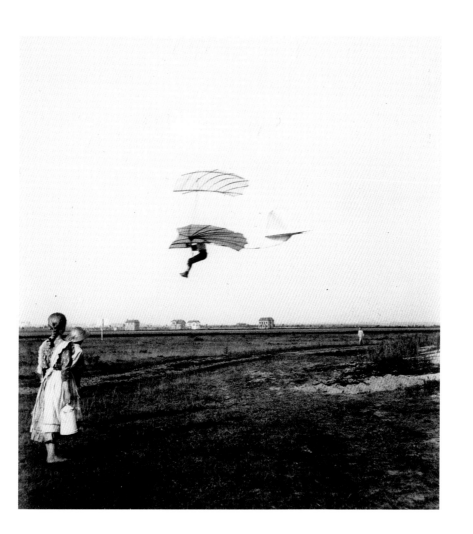

Au revoir, *Le Jaune!* Like a vision from a Jules Verne novel, the airship *Lebaudy I* passes the Eiffel Tower, thrilling the throngs of Parisians below. Most have come to call it *Le Jaune* (Yellow) for its bright coating of lead chromate. Unlike other airships that have floated over the city, this one has a framework of steel tubing built into the bottom of its gas bag, making the craft semirigid. It is also dirigible—steerable—in a breeze.

Creating a powered, lighter-than-air craft that can maneuver in still, let alone windy, conditions has taken many decades—and many lives—to achieve. During a year of test flights before its Paris debut, *Le Jaune* has reached speeds up to 25 miles per hour and set aerial endurance records. But it remains a precarious craft to fly.

On this day, November 20, 1903, *Le Jaune* departs the Champ de Mars for a military review at the Parc de Chalais-Meudon. While landing, a sudden gust blows it into a tree, its envelope bursts, and the dirigible collapses. Luckily, its pilot and engineer are unhurt. Rebuilt as the *Lebaudy II,* it will become the first airship of the French aerial navy.

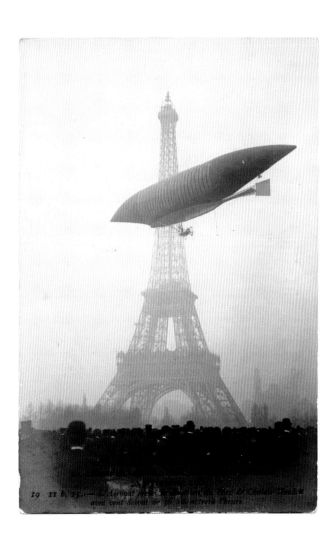

19 11 h. 15. — L'Aéroplane ... de la Porte de Clichy-Plaine à
avec vent debout de 36 kilomètres l'heure.

The Wright approach. Methodical inventors that they were, the Wright brothers followed a systematic program of flight-testing that culminated in their famous 1903 Flyer. Beginning in 1899, they developed a series of experimental flying machines, each built upon the lessons of the previous one.

Their 1902 glider, shown here over Kitty Hawk in the fall of 1903 with their hangar and workshop in the distance, was their last and best experimental glider. They flew it hundreds of times and made many modifications. In its final form, the 1902 glider was the world's first fully controllable airplane. The glider's three-dimensional control system was the key to their final success, and it was that system—not the powered 1903 Flyer itself—for which they sought a patent.

A photo taken when the Wrights returned to Kitty Hawk in 1908 shows the toll the coastal elements had taken on their compound. The hangar roof had collapsed onto their glider, which they had left behind. The Wrights regarded it and their other gliders as research tools, not historical treasures, and they abandoned them once the aircraft had outlived their usefulness. Of the first four aircraft they built, only a single battered wingtip from the 1902 glider remains.

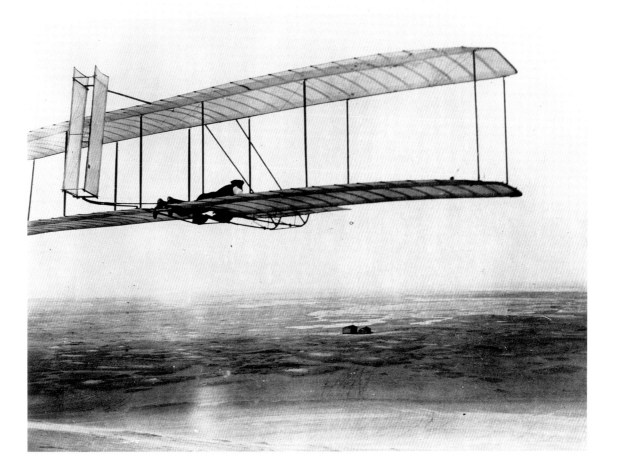

The wrong approach. When the Wright brothers began their aeronautical research in the late 1890s, one publication they consulted was *Experiments in Aerodynamics* by Samuel P. Langley, an eminent American scientist and secretary of the Smithsonian Institution. Langley was bent on creating a powered, human-carrying flying machine, which he called an aerodrome.

While the Wrights would experiment with full-size gliders, Langley had chosen a different course. He planned to build ever-larger, powered, flyable models until he had a craft big enough to carry a person. His first real success was his Aerodrome No. 5. This cyanotype shows it suspended from the beams of his Smithsonian workshop. Driven by a small steam engine and with a wingspan of nearly 14 feet, it flew over half a mile on its first launch in 1896—the first successful flight of a large, powered, heavier-than-air craft.

Langley's huge, full-scale aerodrome didn't fare as well. Launched by catapult from a houseboat on the Potomac in October 1903, it promptly plunged into the river "like a handful of mortar," as one onlooker put it. On its second launch, on December 8, the frail aerodrome simply collapsed upon itself. Nine days later, the Wright brothers flew into history.

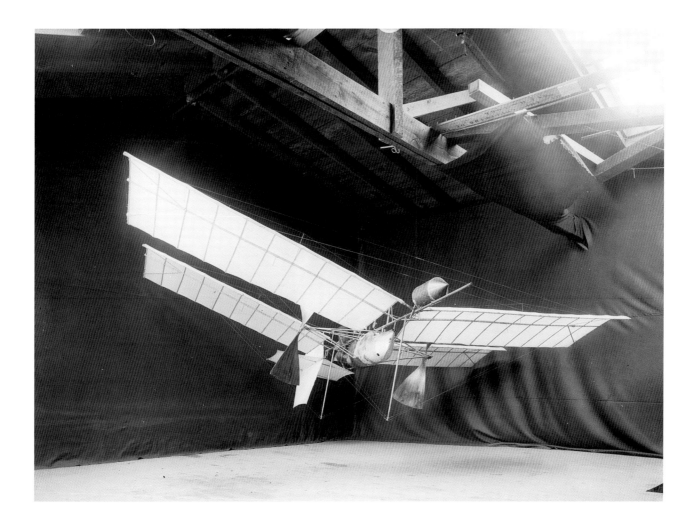

"First to fly." The world's most famous aviator during the first few years of the 20th century was not a Wright but Alberto Santos-Dumont, a wealthy Brazilian living in France. Indeed, on December 18, 1903, the day after the Wright brothers' historic flights, their hometown newspaper featured the headline (buried on page 8) "Dayton Boys Emulate Great Santos-Dumont."

Santos-Dumont pursued public acclaim as much as the Wrights eschewed it. Soon after arriving in France, he began building and flying balloons, usually with much fanfare. He then built and flew some of the first airships, winning prizes and becoming a huge celebrity. He even set a fashion trend when he took to wearing a custom-designed wristwatch while flying—something only women wore—and soon every man had to have one.

Then, on October 23, 1906, he made history with a public demonstration of the airplane pictured here, his 14bis, in which he stands in the balloon-basket cockpit, facing forward toward the box-kite rudder. He took off and made a powered, heavier-than-air flight of 197 feet—the first any European had ever seen. By then the Wrights had made a 24-*mile* flight, but who knew? Proud Brazilians and French alike heralded Santos-Dumont as the "first to fly." Some still do.

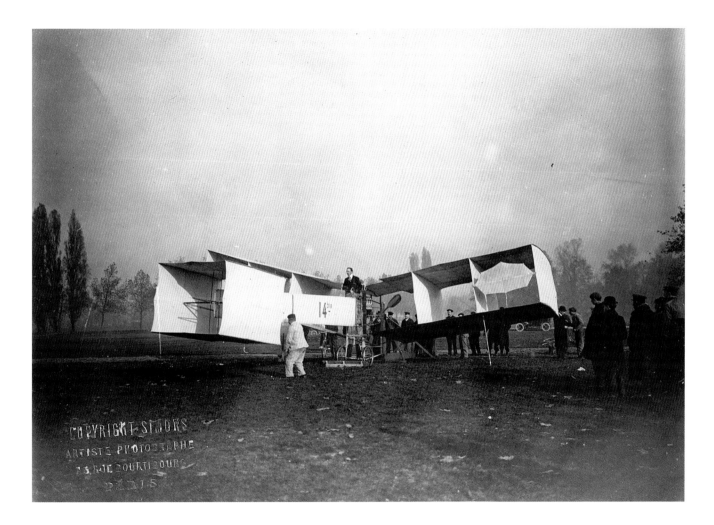

Seeing is believing. While the Wright brothers were keeping quiet about the increasingly amazing performance of their airplanes and guarding the details of their design, the few experimenters who managed even a short hop in the air were being showered with headlines, accolades, and prizes. This must have bothered Wilbur and Orville, as they worked to secure a patent and line up customers, but they continued to bide their time.

In 1908, with patent and contracts finally in hand, they began a public campaign to claim their place in history and to silence those critics who had denounced them as frauds. Wilbur spent the next year in France, the heart of the aeronautical world, performing flights up to almost 2½ hours that utterly astounded all onlookers.

This picture, showing a farmer atop his hay wagon as the Wright Flyer swoops past, was taken in 1909 near Pau in the south of France. It typifies the "old-meets-new" style of aviation photography then becoming popular. It is hard to imagine now what impact such a sight must have had—to watch the future flash by on muslin wings, right over your own oxen-plowed fields.

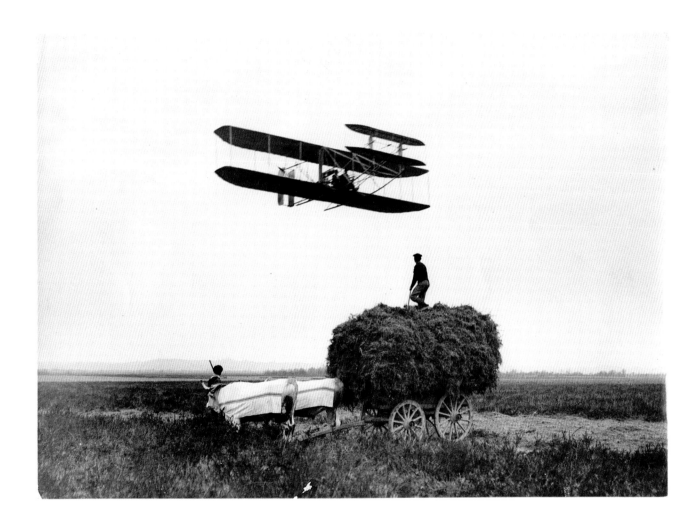

Wings and wonder. Covering the new world of aeronautics for the *New York Herald,* Carl H. Claudy captured this image of his son, Carl Jr., watching Orville Wright in flight over the grounds of Fort Myer, Virginia, just across the river from Washington, D.C., in the late summer of 1908. Orville is performing flight trials for the U.S. Army, which will pay up to $30,000 for the two-man airplane if it meets their performance requirements for speed, duration, and distance.

The trials will end tragically, with the airplane wrecked, Orville seriously injured, and his passenger, Lt. Thomas E. Selfridge, dead—the first person ever killed in a powered airplane crash. But Orville will return in a year with a new airplane. He will complete the trials, the Army will buy the aircraft, and the 1909 Wright Military Flyer will become the world's first military airplane.

Within just a few years, far more advanced military aircraft will be shooting each other down over the battlefields of Europe. But for now, especially to a young boy, airplanes are simply amazing marvels, and flying seems like magic.

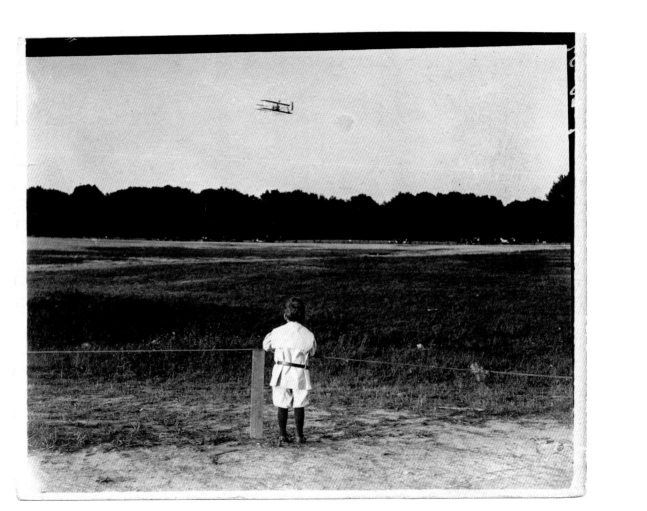

A Fourth to celebrate. Independence Day 1908, Hammondsport, upstate New York. Photographer Harry Benner captures a picture of steely determination: Glenn Curtiss in his *June Bug,* in which he aims to claim the trophy and $2,500 prize *Scientific American* magazine is offering for the first aviator to make a powered, one-kilometer flight. The *June Bug* is the latest and best aircraft of the Aerial Experiment Association, a group of young engineers working under Dr. Alexander Graham Bell. Curtiss, their engine wizard, led the *June Bug*'s design.

In late afternoon, the disagreeably rainy weather clears. Curtiss brings out the airplane, powers up, and rolls off as thousands watch. It lifts into the air and climbs—too steeply!—and Curtiss quickly lands. A misaligned tail is adjusted, and he tries again. This time the *June Bug* rises to 20 feet and flies down the field for two kilometers—twice the required distance—all of it caught on film. It is the first publicly scheduled demonstration of powered flight in America.

The celebration in Hammondsport continues through the weekend, with the Pleasant Valley Wine Company handing out free champagne. Hometown hero Curtiss will soon become a national sensation and an international air racing champion, and Curtiss Aeroplane will become a major aircraft manufacturer.

The sport of kings and queens. Once associated more with county fair showmanship than with horses and hounds, ballooning took on high-class airs in the early 1900s. Wealthy Europeans and Americans adopted sport ballooning as their own, organized aeronautical clubs, and competed against one another in "races"—distance and endurance competitions.

As one contemporary observer put it, sport ballooning appealed "to the healthy, wholesome, steady, cool, level-headed members of society…. It takes the kind of brains that can administer the affairs of a huge business, or can govern a city or a state, or can command an army…. In short, the successful aeronaut is made of the kind of stuff out of which they make the most perfect specimens of American humanity."

Here, H. Eugene Honeywell (center) and a fellow perfect specimen lift off in pursuit of the Lahm Cup, part of the St. Louis centennial celebration of 1909. The goal: to surpass the winning distance flown by Frank Lahm and Henry Hershey in the first Gordon Bennett Cup race, ballooning's most prestigious event. Honeywell and two other participants exceeded that distance but were disqualified on technicalities. A fourth contestant finally claimed the prize by flying nearly to Richmond, Virginia.

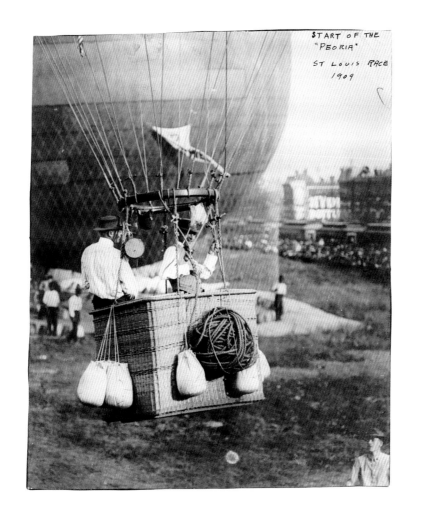

START OF THE
"PEORIA"
ST LOUIS RACE
1909

Blériot conquers the Channel. In 1909 airplanes were fragile, engines unreliable and prone to overheating, weather something to be reckoned with, and water a treacherous place to go down. But with the incentive of a £1,000 prize at stake, Louis Blériot was determined to be the first to cross the English Channel by airplane.

He took off in his monoplane at dawn on July 25 near Calais, France, reached 40 miles per hour, and leveled off at 250 feet. He flew past the French destroyer dispatched to escort him and was soon engulfed in clouds with no compass for guidance. Gusts bucked his airplane and rain pelted it, with the unintended benefit of cooling the straining engine. When he finally sighted the coast of England, Blériot realized he had been blown off course. He wrestled his airplane into the wind to something of a controlled crash landing near Dover.

Blériot's 37-minute flight, the first by an airplane over a large body of water (this photo was taken later), caused a sensation unsurpassed until Charles Lindbergh crossed the Atlantic in 1927. It also caused great consternation in England, for it showed that the island fortress, impregnable by sea, would someday soon be vulnerable by air.

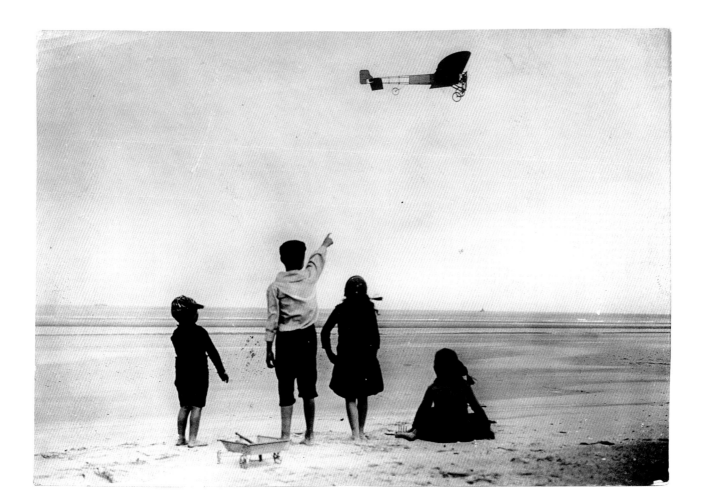

Elegant and assured. Attired in her trademark plum-colored satin flying suit with hood, Harriet Quimby sits within the ungainly assemblage of wire, wood, and cloth that bears her aloft. She had a face that cameras loved. Those who wrote about her exploits always mentioned her great beauty, as though it somehow made her achievements that much more remarkable, her end that much more tragic.

Although first drawn to the stage, journalism became her career. She wrote hundreds of articles for *Leslie's Illustrated Weekly*—household tips, theater reviews, advice on maintaining an automobile, opinions on social issues, stories about her worldwide travels illustrated with her own photographs. She loved motoring—she bought herself an automobile—and was drawn to other pursuits considered daring for a woman. She especially attracted attention in pursuit of her final passion, flying.

Quimby was a pilot for only 11 months, from the day in 1911 when she became the first woman in America to earn a pilot's license, through her historic solo crossing of the English Channel, to the day she plummeted to her death after being thrown from her airplane at an aviation meet, in full view of a horrified crowd.

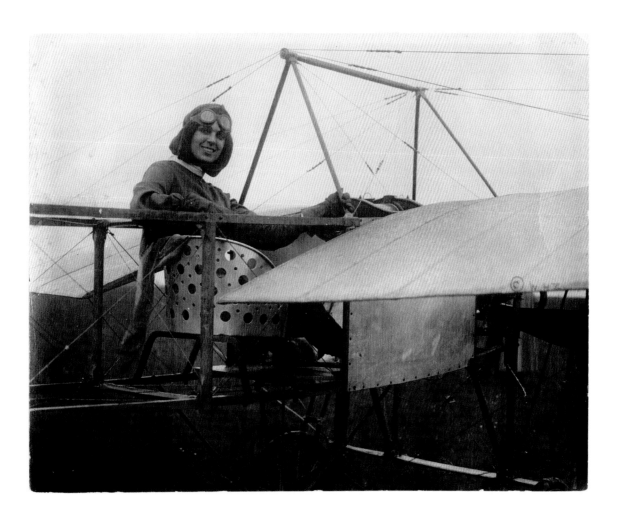

Moment of release. His hand raised, the pilot signals his ground crew to let go. Seconds before, engine revved up, propeller chewing at the air, his brakeless Deperdussin racer pulled against their restraining hands. Now the airplane lunges forward, two crewmen in the rear fall back, two more behind the wing leap out of the way. A balloon bobs in the wind, signaling its direction. In the distance, crowds pack the grandstand to witness one of the great spectacles of this new aerial age.

The first flyable airplanes had barely struggled into the sky when air shows and competitions began to appear throughout Europe. These events drew tens to hundreds of thousands of spectators, who watched their national favorites competing in contests of speed, distance, and altitude, daring the devil in their dangerous aeronautical contraptions and (usually) defying death.

This scene probably depicts René Vidart taking off from Calais, France, toward the end of the Circuit of Europe. The 1,000-mile racing tour began and ended in Paris and circled through France, Belgium, Holland, and England from June 18 to July 7, 1911. Fifty-two aircraft lined up for the start; seven completed the full circuit, including Vidart, who placed third.

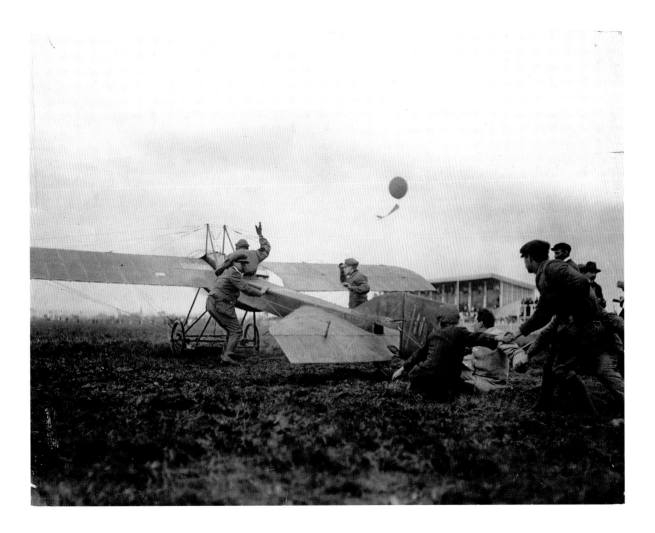

Seeds of an industry. The brothers Loughead (Allan, third from left; Malcolm, second from right) pause with other members of their Loughead Aircraft Manufacturing Company while constructing their F-1 flying boat. When completed in 1918, the 10-passenger seaplane will be the biggest yet built, but it won't be enough to keep the fledgling company afloat.

The Lougheads' Santa Barbara firm was not their first attempt to build airplanes—there was the short-lived Alco Hydro-Aeroplane Company a few years before—nor would it be their last. After Malcolm went east and made his fortune by developing a hydraulic brake system for automobiles, Allan created yet a third aircraft company. To capitalize on the reputation of his brother's successful brake business, Allan, like Malcolm, adopted for his company a more easily pronounceable version of their name: Lockheed.

Lockheed Aircraft would go through its own ups and downs, with and without its namesake. The Lougheads would found two more short-lived companies before finally giving up on aviation. But their name would become associated with some of the most successful and innovative aircraft ever built. Another person who would make a lasting name for himself probably appears in this photo (third from right) as well—John K. "Jack" Northrop.

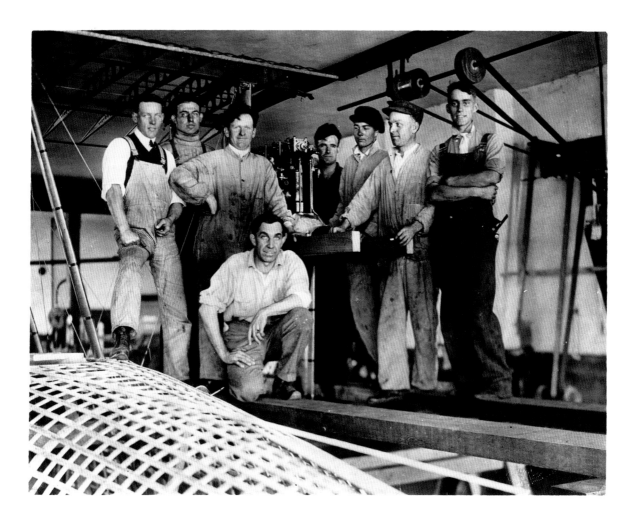

Doing her part for the war effort. Most likely her name isn't Rosie, and she's certainly not a riveter, airplane wings being made of fabric and wood. But like her counterpart in another war a quarter-century later, she's blazing a social trail. Her husband, if she has one, may not approve of her working; he probably isn't keen about that outfit she's wearing either. She doesn't yet have the right to vote, but what she does have is the audacity to do a man's job.

Her opportunity is courtesy of the U.S. Navy, which opened the Naval Aircraft Factory at the Philadelphia Naval Shipyard during World War I to help assure its airplane supply, evaluate contractor costs, and develop experimental aircraft. The Navy soon decided to hire female workers and set up a training program specifically for them. Many, like this young woman, worked on assembling wings; others covered the wings, painted aircraft, or worked in the sawmill or machine shop. By Armistice Day, women made up almost a quarter of the factory's work force.

The Naval Aircraft Factory stopped producing aircraft toward the end of World War II, a conflict that prompted a resurgence of women entering the workforce.

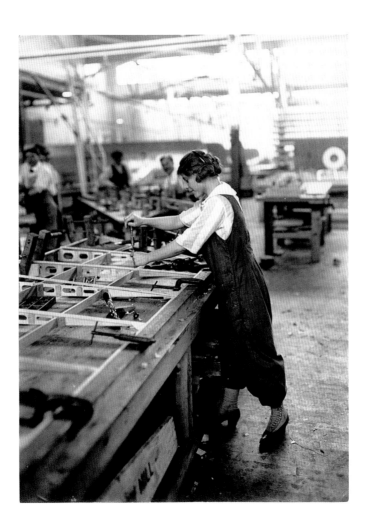

Interlude. The full weight of war is yet to descend upon these members of Royal Flying Corps No. 3 Squadron. Stationed near Amiens, on the Somme River north of Paris, probably in the fall of 1914, they await the call to duty, most likely a reconnaissance mission.

The nearest aircraft in view is a Blériot XI-2, and behind it a Blériot Parasol, both two-seater descendants of the first airplane to cross the English Channel in 1909. Only two years after that, an airplane was first used in combat, and now as the Great War sweeps across Europe, nations are scrambling to produce warplanes and assemble air forces. Although widely used, the frail Blériots are barely suitable even for observation duty and will soon be relegated to training new pilots. Newer, sturdier biplanes will take over most frontline operations and will pioneer new kinds of warfare.

Formed in 1912 with the creation of the Royal Flying Corps, No. 3 Squadron was the first RFC unit equipped with heavier-than-air craft—thus its motto, "The third shall be first." It traded its Blériots for Sopwith Camels and other biplanes, and in later wars for Hawker Hurricanes, Harrier V/STOL aircraft, and Eurofighter Typhoons.

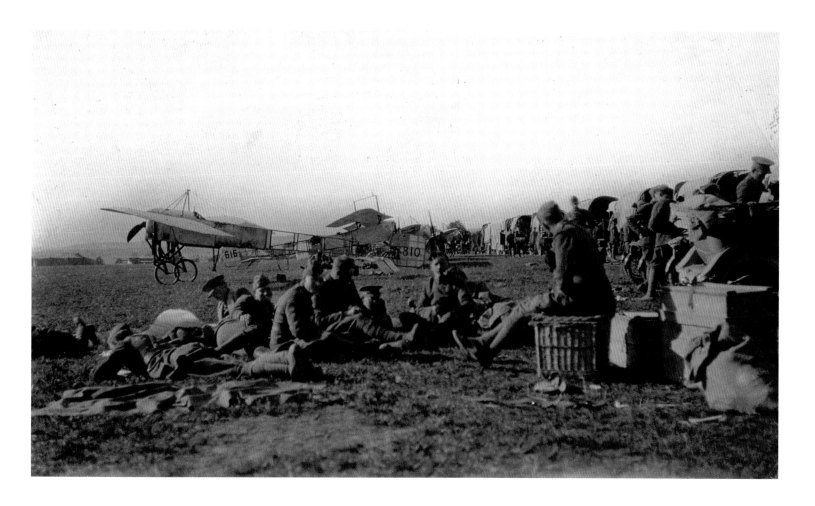

The battleground from above. Trenches stitched across the patchwork of farmland near a French village mark this World War I aerial reconnaissance photograph. By the spring of 1915, less than a year into the conflict, the opposing armies had dug lines of trenches extending more than 400 miles from Belgium to the Swiss border. During four years of grinding warfare that yielded many millions of battlefield casualties, the lines barely moved.

Also caught in the frame is a French or British Nieuport 11, a single-seat fighter also used for observation. Tracking the movement of enemy forces, traditionally done by cavalry, was the first effective military use of aircraft. Observation aircraft played decisive roles in some of the early battles, before the combatants began developing better defenses against them, such as airplanes expressly designed to shoot down other airplanes.

Aerial photography of the battlefield proved less successful. Slung over the side of the fuselage beside the pilot, early aerial cameras were cumbersome and difficult to use while flying. Even if sharp photographs unobstructed by smoke or haze could be taken, by the time they were developed and distributed for analysis, they were often already obsolete.

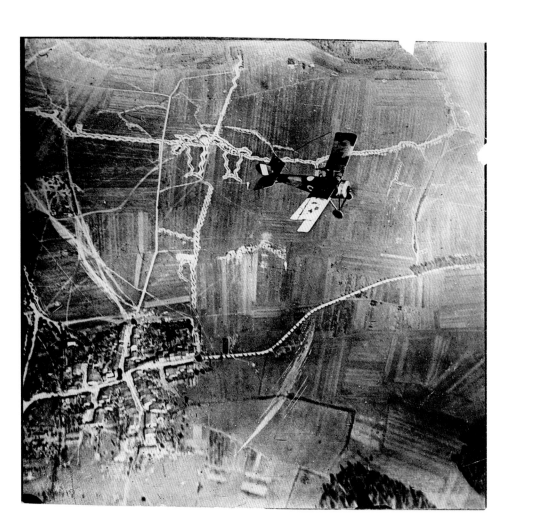

The "Arizona balloon buster." "I envied the flyers," wrote one American infantryman. "Here was I in mud up to my knees…. The other fellows were sailing around in the clean air while I had to duck shells all the time…. They never seemed to get hurt."

Frank Luke Jr. was one of those envied fellows. While serving with the 27th U.S. Aero Squadron in France in 1918, 2nd Lt. Luke quickly became America's leading ace, shooting down four airplanes and 14 observation balloons, most within a week. He earned the Medal of Honor for his final action, in which he destroyed three enemy balloons while under heavy ground fire and pursued by German Fokkers. Wounded, he descended to low altitude and killed or wounded several enemy troops before making a forced landing. Surrounded, he drew his pistol and fought to his death.

Luke was all of 21, and his fabled combat career lasted only a month and a half. Flying, as it turned out, was a deadly occupation, and far less gallant and glamorous than weary doughboys were led to believe. Luke joined the ranks of as many as 10,000 other aviators who perished during the war.

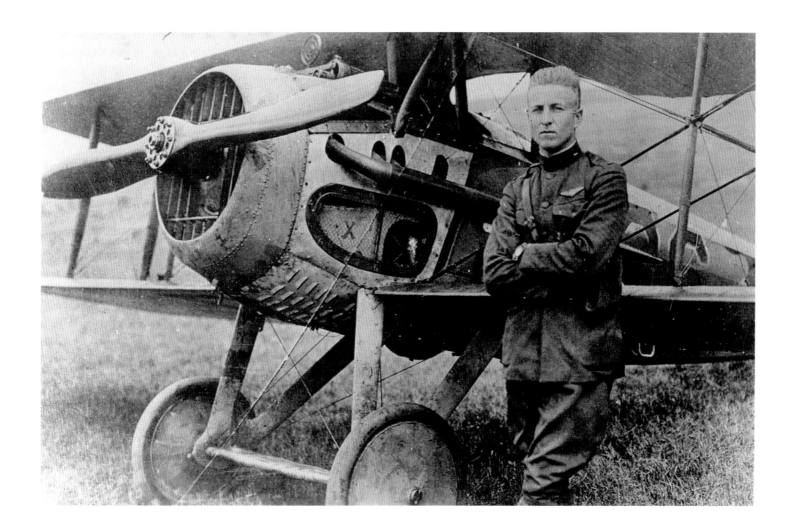

New tactics and weapons. For soldiers in the trenches, the most harrowing of the airplane's new roles must have been ground attack, and the Halberstadt CL.IV was well designed for it. Used to support infantry assaults, it helped Germany finally break through the Allied lines in the spring of 1918.

The Halberstadt could kill coming and going. Approaching at low altitude, the pilot fired ahead with a fixed Maxim machine gun, while the rear-facing observer behind him raked the trenches with a swivel-mounted Parabellum as the plane passed by. The observer served as bombardier as well, pitching grenades and dropping small bombs. Here, a ground crewman hands the observer improvised bombs made of stick grenades. The finned canisters hanging from the side are mortar bombs.

Some higher-flying aircraft were armed with another fearful weapon: the fléchette, or aerial dart. About the size of fountain pens, fléchettes were carried aloft in boxes of up to 500, then dropped or dumped overboard. Falling from a high enough altitude, they could pierce a man or a horse. Fléchettes proved more terrifying than effective, but they gave the boys on the ground one more reason to wish they too had wings.

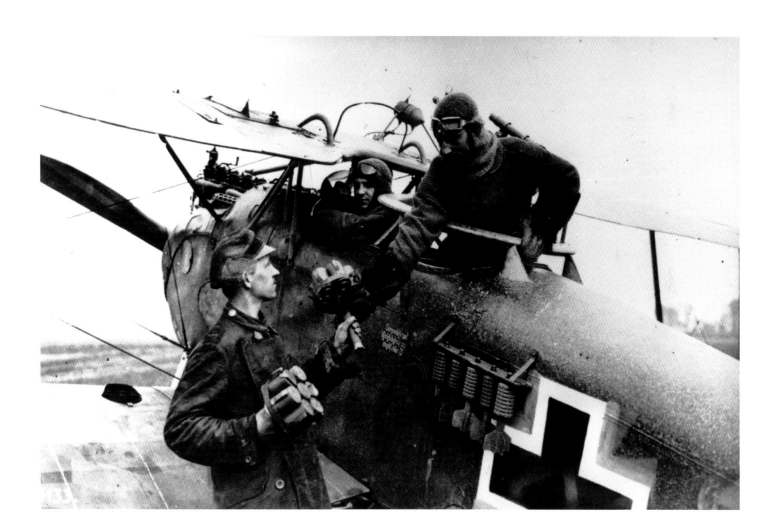

"Ace of aces." The concept of the ace arose during World War I as a way to recognize top pilots and boost morale. The number of victories required to achieve this status varied from nation to nation; the United States settled on five. Some European fighter pilots wracked up phenomenal numbers of "kills" against fighters, observation planes, and balloons.

America's highest scoring ace, or "ace of aces," at war's end was Capt. Eddie Rickenbacker, who scored 26 victories with the 94th Aero Squadron. (His airplane bears the squadron's famous "Hat in the Ring" emblem.) Rickenbacker first gained fame as an automobile racer. He competed in several Indianapolis 500 races and returned to the sport after the war as owner and president of Indianapolis Motor Speedway. World War II rekindled his aviation fame. While on a tour of Pacific bases, his plane went down at sea, and he and his crew survived 22 days on rafts without supplies before being rescued.

But Rickenbacker's most important, if less sensational, achievements were in the realm of civil aviation. As president and general manager of Eastern Airlines before and after World War II, he helped shape Eastern into one of the nation's leading airlines.

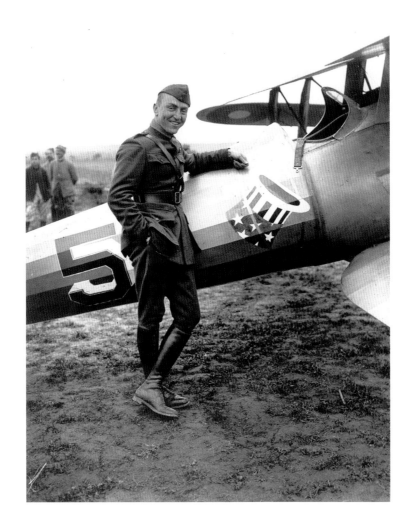

First across the Atlantic. Charles Lindbergh became world famous for crossing the Atlantic alone, but the first transatlantic flight occurred eight years earlier. Three U.S. Navy Curtiss flying boats, each with a crew of six, were involved: NC-1, NC-3, and NC-4. (NC-2 was cannibalized for parts.) The five-leg flight began on May 8, 1919, at the naval air station at Rockaway Beach, New York. It followed a route to Nova Scotia; Newfoundland; the Azores in the North Atlantic; Lisbon, Portugal; and Portsmouth, England.

Mechanical problems afflicted all three planes at the start, but the real drama occurred on the 1,300-mile Newfoundland–Azores leg. Twenty-one Navy destroyers stationed along the route helped guide the airplanes through the night, but as the fliers neared the Azores at daybreak, fog put them off course. NC-1 and NC-3 set down in rough seas to take bearings and never took off again. A freighter rescued the crew of NC-1, which later sank. Damaged, NC-3 motored on to the Azores by water.

Only NC-4 reached the Azores by air and flew on to Lisbon (shown here) and Portsmouth. The airmen were hailed as heroes, but their 24-day adventure was soon obscured by the blizzard of aviation records set by others that followed.

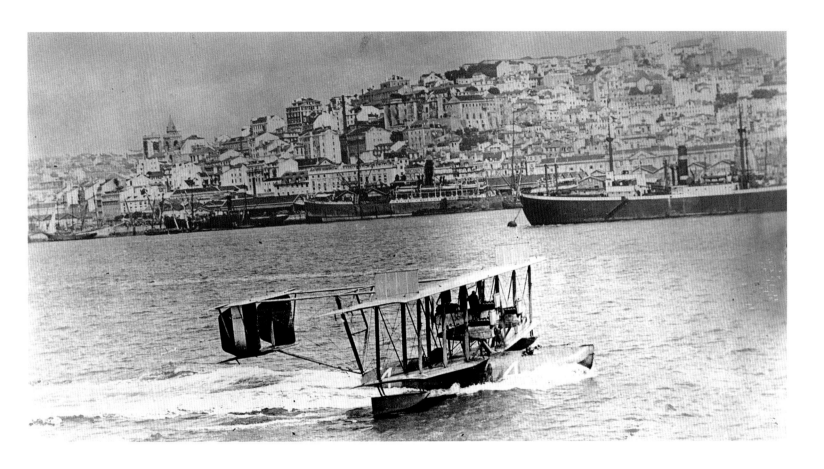

Booze, beauty, and the *Buckeye*. Early commercial airlines faced insurmountable odds. Costs were high, planes small, and the passenger market limited. Flying was considered risky business, in more ways than one. Aeromarine Airways prospered more than most, due in no small part to a national scarcity of gin and rum.

Aeromarine began operating between Key West and Havana in 1920—coincidentally, the same year the National Prohibition Act went into effect. The following year, its converted U.S. Navy Curtiss flying boats also began flying from mainland Florida to Bimini and Nassau in the Bahamas, which, like Cuba, were "wet," alcoholically speaking. Wealthy Americans, thirsty for the "intoxicating liquors" now so inconveniently illegal stateside, took to hopping the "Highball Express" to the Caribbean for a bit of offshore inebriation.

But despite its seasonal schedules of both northern and southern routes, comforting safety record, and accommodations fit for a tycoon, Aeromarine could not make a go of it over the long haul. Not even such creative publicity efforts as this photo of Aeromarine's *Buckeye* embellished with bathing beauties could offset the company's financial challenges. Prohibition was repealed in 1933, but it outlasted Aeromarine by nine years.

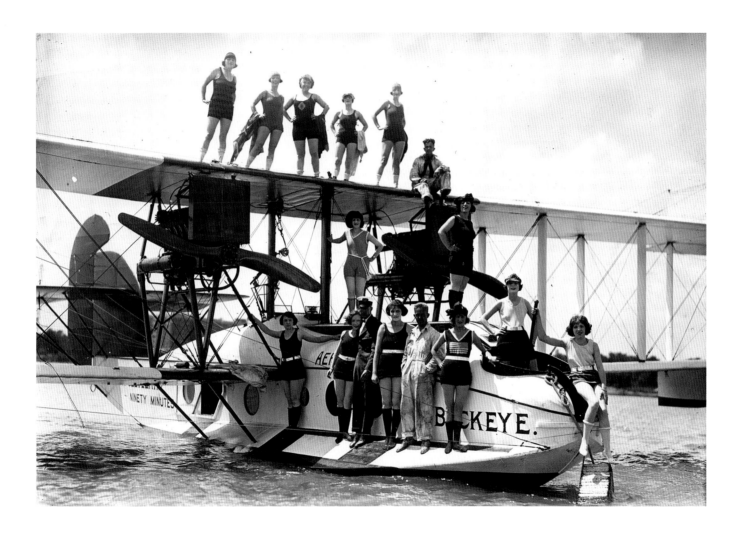

New Orleans in Iceland. The most ambitious of the early record flights was that of the Douglas World Cruisers, four U.S. Army aircraft that set out to circle the world in 1924. Only the *Chicago* and *New Orleans* completed the full 175-day journey. The *Seattle* crashed in fog in Alaska early in the trip, and the *Boston* was lost at sea after an emergency landing en route to Iceland. All crew members survived.

This photo was taken during the lengthy layover in Reykjavik, where the crews awaited weather favorable for continuing on to Greenland. They spent their time sightseeing and shopping, being wined and dined, and tending to their aircraft. They pulled the *New Orleans* from the water for maintenance. "The hauling up was a great treat to the locals & a great crowd stood around all day," reported the *Chicago*'s mechanic, "the police protection being all that enabled us to work at all."

The U.S Navy vessels supporting the flight caused a stir as well, as they were the first American warships the Icelanders had ever seen. One appears in the far distance, a striking contrast to the sailing ships in Reykjavik harbor and another measure of how fast technology was changing the world.

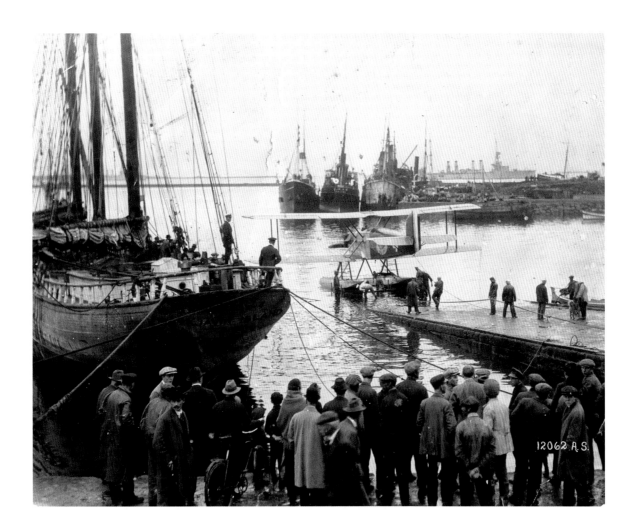

Going my way? Nothing had as exciting a roar during the Roaring '20s as a flock of Curtiss Jennys barnstorming into town with the promise of aerial thrills and heart-pounding stunts. They were probably the first airplanes you ever saw, and the first that gave you the chance to go up for a ride. And then there were the daredevil loops and rolls and spins you watched from the ground and that kept you craning your neck and holding your breath.

The postwar barnstorming boom resulted from a huge surplus of government airplanes, aviators, and, apparently, adrenaline. For a few hundred dollars, you could snap up the kind of airplane you learned to fly in the Air Service, then do things with it that would have gotten you court-martialed—and make good money at it too. The key was to keep the thrills coming and put on a better show than any other bunch of flyers and aerialists that might pass through town.

Wing walking was especially exciting and dangerous. Many wing walkers developed their own specialties. Gladys Ingle, shown here about to execute a midair transfer from one Jenny to another, liked to perform target practice with her bow and arrow while on top of the top wing.

Flying the mail. Our modern airline system has its roots in the U.S. Air Mail Service, which flew the mail from 1918 to 1927, when the Post Office contracted out the last of its routes to commercial airlines. The Air Mail Service laid the groundwork—literally and economically—for a national air transportation system by pioneering routes, building airfields and lighted airways, and establishing reliable service from coast to coast.

The first transcontinental route, completed in 1920, passed through Fort Crook near Omaha, Nebraska, where photographer Nathaniel Dewell documented the Air Mail Service's operations. Dewell served as a photographer for the U.S. Army Signal Corps and then became a commercial photographer, capturing many aspects of Omaha life, from buildings and businesses, to people and social institutions, to Indian powwows and holiday parades.

Fort Crook became a training base for the Army's balloon service in 1918. In the 1920s a large area was leveled, seeded, and made suitable for airplanes and then named Offutt Field. Many of the B-29s (including the atomic bombers that struck Japan) were made at a Martin plant at Fort Crook. After World War II, Offutt Air Force Base became home to the Strategic Air Command.

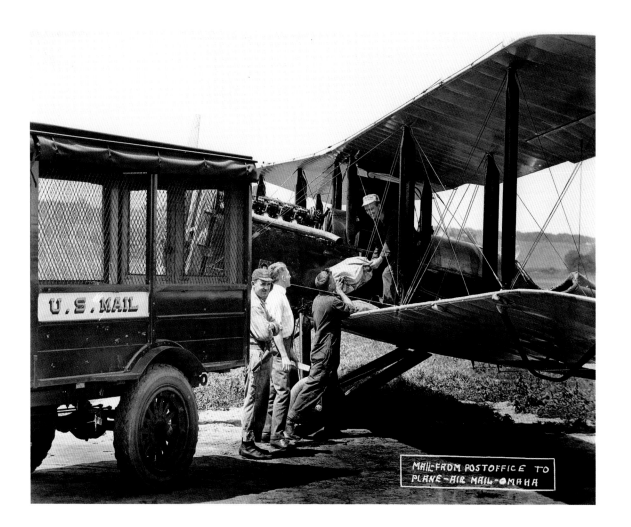

MAIL FROM POST OFFICE TO
PLANE - AIR MAIL - OMAHA

A pilot's best friend. The pilots were the stars of the U.S. Air Mail Service—some became legendary—but the mechanics and ground crews were the unheralded heroes behind its success. Here, Nathaniel Dewell captured one of them working on a de Havilland DH-4's Liberty engine.

Like most American aviators after World War I, Post Office pilots first flew Curtiss Jenny trainers, outfitted with bigger engines and a mail compartment. While about as reliable as a 1918 airplane could be, they had their drawbacks. Air mail pilot Earnest Allison quipped, "I always considered it a very safe airplane, because the carburetor would vibrate the airplane so badly that it would shake the ice off the wings."

The Service's airplane of choice soon became the British-designed de Havilland, a light bombing and observation aircraft from World War I. Modified for mail service (the pilot was moved back to the rear cockpit to make room up front for mail and gas), it could fly farther and faster and carry more mail than the Jenny. Still, the punishing flying conditions their airplanes had to endure made air mail pilots grateful for those dedicated grease monkeys back on the ground.

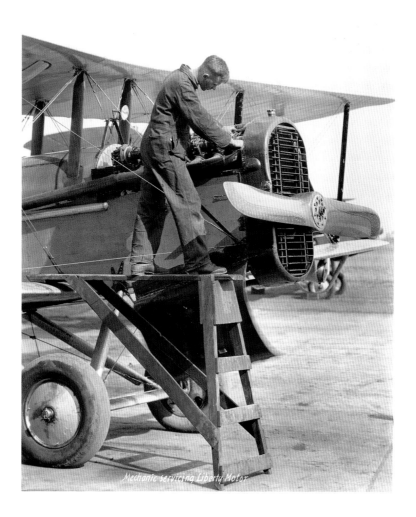

Mechanic servicing Liberty Motor

The airmen. They are young, daring, self-assured. They live to fly. Packed into their bulky winter suits, critical for flying in an open cockpit, they perform about the most dangerous government work one can find outside of armed combat: they fly the mail, in all kinds of weather, over all kinds of terrain.

They fly in the dark with few lights to guide them. They fly in rain or in snow with their wings icing over. They fly at treetop level in the fog, searching for the rivers or railroad tracks or water towers that mark their way. Jack Knight, far left, will become famous for his heroic part in the first coast-to-coast, day-and-night air mail flight. He will retire from United Air Lines, having flown more than two million miles. "Wild Bill" Hopson, second from right, the most colorful of air mail pilots, will sign on with National Air Transport to carry the mail, and will die doing it.

More than 30 pilots, nearly one in six, hired by the Post Office will be killed in service. Ran into tree in fog. Struck radio mast. Caught fire in air and crashed. Plane stalled and crashed. Forced landing in snowstorm, struck trees. Crashed and burned. Crashed and burned.

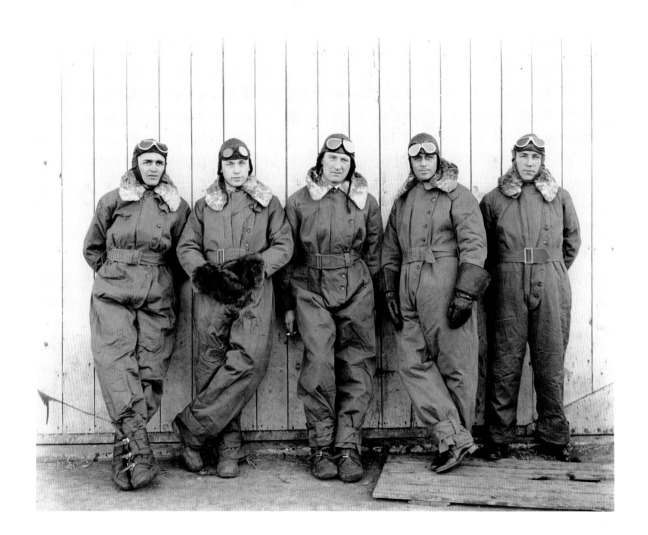

Almost famous. He looks like nothing more than an excited boy with a new toy, a custom-designed airplane Ryan Airlines built just for him. Harry A. "Jimmy" Erickson, San Diego's "Flying Photographer," was on hand at Ryan Field out at Dutch Flats on May 9, 1927, to take the air mail pilot's picture. The next day the 25-year-old will fly the airplane to St. Louis, and then on to New York, setting a transcontinental speed record along the way.

Erickson's image captures the pilot's boyish charm and excitement, along with a broad smile he rarely displays in photographs. But it provides no hint that within 12 days, Charles Lindbergh, having flown on to Paris, will be the most famous man alive.

For America, his flight will become a watershed event; for Lindbergh, it will become both a boon and a burden. But after a life marked by adventure, tragedy, controversy, and devotion to aviation and environmental causes, he will be remembered most for that singular feat. One day in a Smithsonian museum, he will climb into the *Spirit of St. Louis* once more and quietly sit, reflecting back to when he was just an eager young man with a new airplane, alone in the sky.

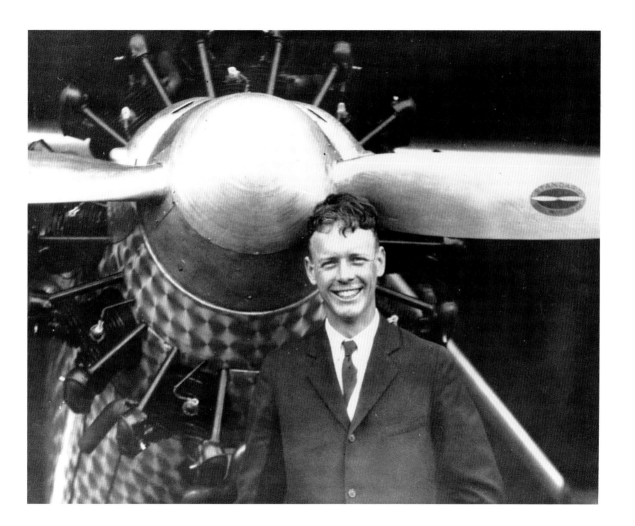

The rocketeer. Using rockets to launch payloads aloft, let alone people, was still science fiction in the 1920s. When Dr. Robert Goddard suggested in a research paper that rockets might someday reach the Moon, the idea generated both excitement and ridicule. The *New York Times* flatly asserted that, as any high-schooler knew, rockets wouldn't work in the vacuum of space.

Goddard poses here by a launch stand holding his first flyable liquid-fuel rocket. The rocket engine is at the top, the gasoline and liquid oxygen tanks below. Black powder had been used for centuries to launch fireworks and war rockets, but Goddard was one of a few visionaries who deduced that liquids would provide more energy. On March 16, 1926, he successfully launched the rocket—the first one powered by liquid fuel ever to achieve flight.

Because Goddard was so secretive about the details of his work, he had little influence on rocketry development. But his achievements proved that the idea of using rocket propulsion for spaceflight was no crackpot scheme. As for his condescending critics, the *Times* finally conceded in print that Goddard had been correct—in 1969, on the eve of the first Moon landing.

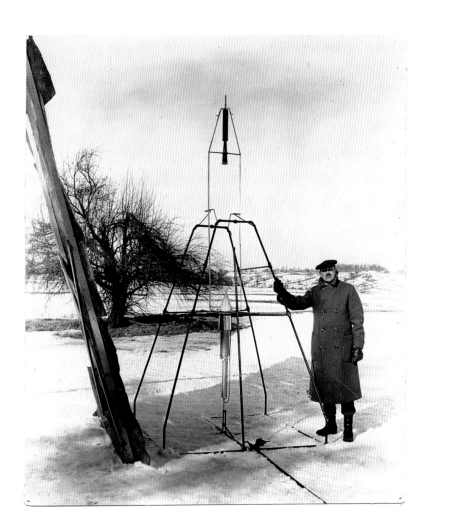

Racer at rest. Popular enthusiasm for aviation peaked in the years between the world wars, the so-called Golden Age of Flight, a period that also saw rapid advancements in aviation technology and design. This enthusiasm and innovation were due in no small part to the rise of air racing as an arena for both civilian and military competition.

The era's four major races—the international Schneider Trophy race and the Pulitzer, Thompson, and Bendix trophy races in the United States—made many a former barnstormer a star. Governments and military services supported or sponsored teams in the Schneider and Pulitzer races, putting national honor and service prestige at stake.

A French industrialist established the Schneider Trophy to help advance seaplane technology. Traded back and forth among France, Great Britain, Italy, and the United States, the trophy became the permanent possession of Britain after three wins in a row. The Supermarine S.6B pictured here near Southampton, England, secured that final 1931 victory. A streamlined metal monoplane with a powerful Rolls-Royce engine, the S.6B was a far cry from the biplanes of the Schneider's early years. It evolved into another Supermarine design that would prove crucial to Britain in the years ahead: the Spitfire.

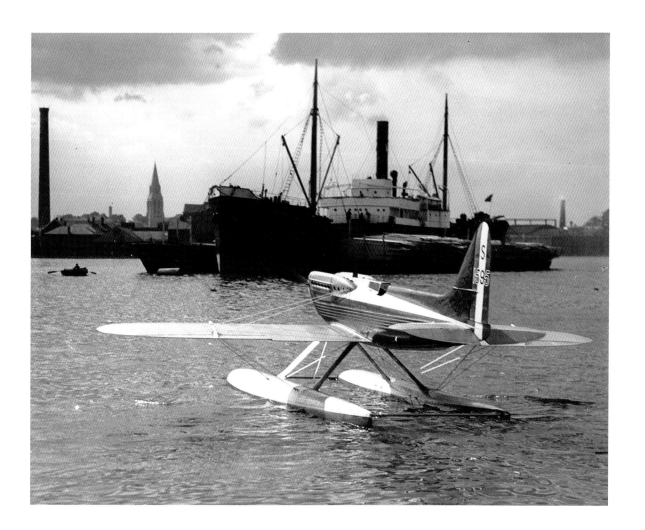

"Jimmy" Doolittle. Long before he helped boost America's morale in the bleak months after Pearl Harbor, James H. Doolittle was one of the nation's top record setters and air racers.

In 1922 he became the first person to cross the country in less than 24 hours, and later the first to do so in under 12. He was the first pilot to perform the dangerous outside loop (the pilot on the outside of the loop all the way around). He was the only one ever to win the triple crown of air racing: the Schneider, Bendix, and Thompson trophies.

But Doolittle was far more than just another pilot with a thirst for speed and a talent for getting the most out of an airplane. He earned a doctorate in aeronautical engineering, studied the effects of stress on aircraft structures, helped develop high-octane fuel, and promoted the development of flight instruments for pilots. In 1929 he climbed into a biplane, pulled a hood over the cockpit, and became the first to take off, fly, and land entirely by instruments. In short, he was a racing champion, scientist, engineer, test pilot, war hero, and more—the renaissance man of the Golden Age of Flight.

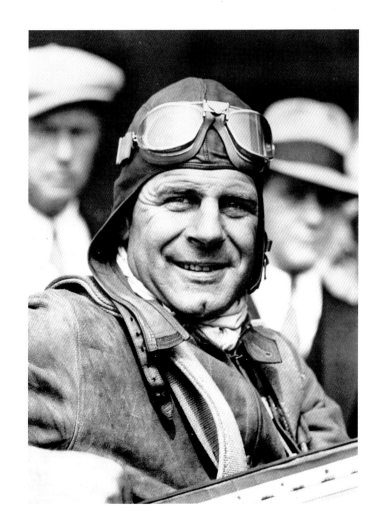

Rounding the pylon. The National Air Races were the Indy 500 of the air, the pre-eminent air racing event in the United States. The multiple-day extravaganza featured numerous aerial events and races, including the Pulitzer Trophy speed race, the main event during the 1920s.

In the 1930s, the most coveted prizes were the Thompson Trophy and the Bendix Trophy. The Thompson was a closed-course, 100- to 300-mile race around pylons, a nail-biting test of speed and nerves. Unlike the Pulitzer, in which airplanes competed one at a time for the fastest speed, pilots in the Thompson flew all at once. The Bendix was a cross-country race, usually from Burbank, California, to Cleveland, where the National Air Races finally settled. Like automobile racing, air racing was a dangerous affair; more than a third of the Thompson and Bendix champions were killed during races.

Banking around a pylon here at the 1931 Nationals is Johnny Livingston in his clipped-wing Monocoupe 110 Special, an airplane he made famous. One of the Golden Age's winningest pilots, Livingston rarely placed less than second. He made a lasting impression on a fellow pilot from Iowa, Richard Bach, inspiring him to write the 1970s best-seller *Jonathan Livingston Seagull*.

Colonel Roscoe in his Meteor. No one was more golden during the Golden Age than Roscoe Turner. With his dashing appearance and flair for showmanship, he roared into racing via the usual barnstorming route. A crowd favorite, he took to wearing a quasi-military outfit of his own design and adopted a pet lion cub named Gilmore as his mascot and flying companion. The Nevada governor gave him the honorary title of colonel, and the Mississippian liked the genteel sound of it so much that he adopted the title too.

His fellow racers figured this dandy was more flash than flyer, but Colonel Roscoe quickly proved them wrong. He placed third in the Bendix and Thompson races in 1932, then went on to win them both. He set seven transcontinental speed records and repeatedly won the Harmon and Henderson trophies as outstanding aviator or racer.

By the late 1930s, flying his new Turner Meteor, Roscoe had become the man to beat at the Nationals. He became the first two-time Thompson winner in 1938, then astonished everyone in 1939 by winning the Thompson yet again. Then, America's top racer simply quit racing. Always the master showman, Turner knew precisely when to exit the stage.

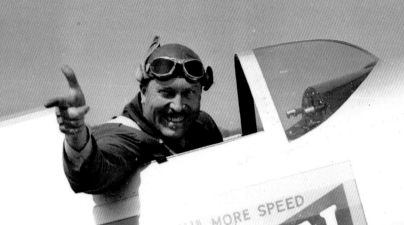

Thoroughly modern Amelia. She stands beside a Cord Phaeton and a Lockheed 10E Electra at Purdue University, where she councils young women on careers. Amelia Earhart sets a high standard. She is a daring pilot, an ardent feminist, a fashion designer, a smart dresser, and one of the world's most famous aviators.

The sleek Phaeton is as stylish and unconventional as Earhart herself: low slung with a coffin-shaped nose, horizontal hood louvers, flowing pontoon fenders, hidden headlights. The Cord's debut was the talk of the 1935 New York Auto Show. The 10E is the latest, most powerful Electra, Lockheed's first entry into the all-metal airliner market. Earhart has big plans for it: a flight around the world following the equator, her most audacious aviation record attempt yet.

Lockheed's Electras will soon pass into obscurity, rendered obsolete by the likes of the Douglas DC-3. The Auburn Automobile Company will pass into bankruptcy at the end of 1937, and its elegant Phaeton will come to be regarded as one of the great classic automobiles. Amelia and her Electra will vanish in the South Pacific, three-fourths of her way around the world, and pass into legend.

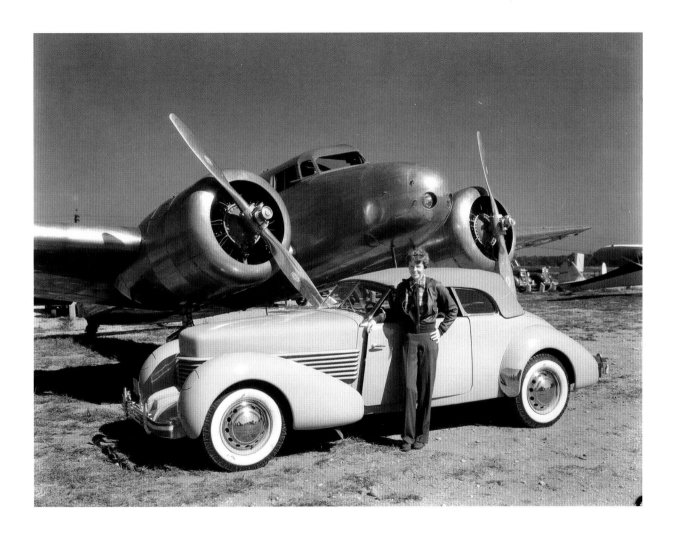

Glider, by Groenhoff. A glider from Lithuania awaits its next launch at the 1937 gliding and soaring meet near Elmira, in hilly upstate New York. In the 1930s, Elmira became the center for gliding and soaring in the United States, and its chief chronicler was German immigrant Hans Groenhoff.

Groenhoff's younger brother, a famous glider and sailplane pilot in Germany, introduced him to the sport. When he died during a gliding contest in 1932, he left Groenhoff two high-quality cameras. Coupling his interest in flight with a talent for taking artful pictures, Groenhoff became one of the world's foremost aviation photographers.

Fascinated with skyscapes, Groenhoff used clouds and sky as stage settings for his aircraft photographs. His pictures are characteristically striking in composition. They often incorporate other objects, such as the pilot and cockpit canopy here, as subtle but key elements. Groenhoff's photography spanned half a century. His early work focused on Elmira and the New York City area. Later, Florida and the Bahamas provided a colorful backdrop for his elegant compositions. He captured the development of U.S. military aviation before and during World War II, and his early color photography set a high standard for that emerging art form.

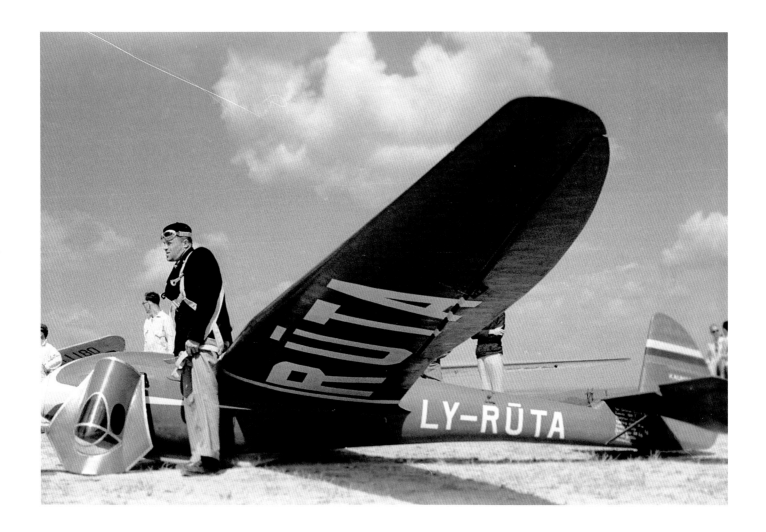

The bush leagues. Some of the most adventurous aviators heeded the call of the wild and headed north to Alaska to become bush pilots. Airplanes proved a real boon to the Alaskan and Canadian frontier. Settlements were far flung and isolated, and the territory had few roads or rail lines. Waterways froze during the long winters. Many places could only be reached by dog sled.

Bush pilots provided a critical lifeline, carrying mail, food, medicine, people, and more. It was hazardous work. Pilots had to be skillful and daring, and their mechanics, who often accompanied them, resourceful. They had to deal with harsh and untamed environments, rough and unpredictable weather, sub-zero temperatures, and forced landings or breakdowns in remote areas. In bitter cold, pilots had to drain the oil from their engines after flight to prevent it from congealing, then heat the oil and engine before starting up again. Floats or skis were usually more useful than wheels.

Airlines had to compete with boat and dog sled operators for mail contracts. Pan American Airways flew many of the air mail routes. This Lockheed 5B Vega being refueled from the back of a truck flew for Pacific Alaska Airways, a subsidiary of Pan American formed in 1932.

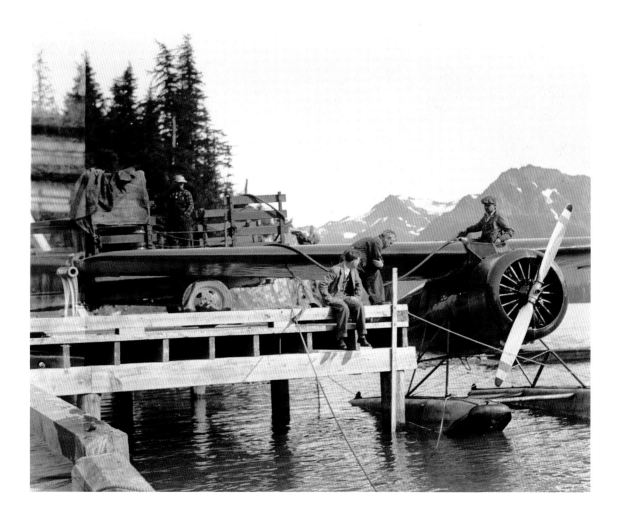

An airline's bread and butter. Cargo handlers load air express packages into the wing compartment of a Ford Tri-Motor. This commercial photo, taken in the 1930s for Transcontinental and Western Air (TWA) at Kansas City, Missouri, portrays these unheralded ground crew workers as efficient, tidy, and surprisingly clean.

Thanks to the reputation Ford built with automobiles, its Tri-Motor—the "Tin Lizzy" of the air—helped popularize air travel when airlines were just starting to spread their wings. But the "Tin Goose" was not efficient enough and demand was not strong enough for airlines to make money carrying only passengers. They had to rely on transporting mail and packages to pay the bills.

TWA formed in 1930 when Transcontinental Air Transport (TAT) merged with part of Western Air Express. Both had tried to make a go of passenger service, Western in the west and TAT with its air-rail transcontinental service—passengers traveled in Tri-Motors by day and switched to trains for the night. The U.S. Post Office contracted with TWA to fly the mail along the newly created New York–Los Angeles route. TWA did so well that it later expanded internationally. It kept its familiar acronym but changed its name to Trans World Airlines.

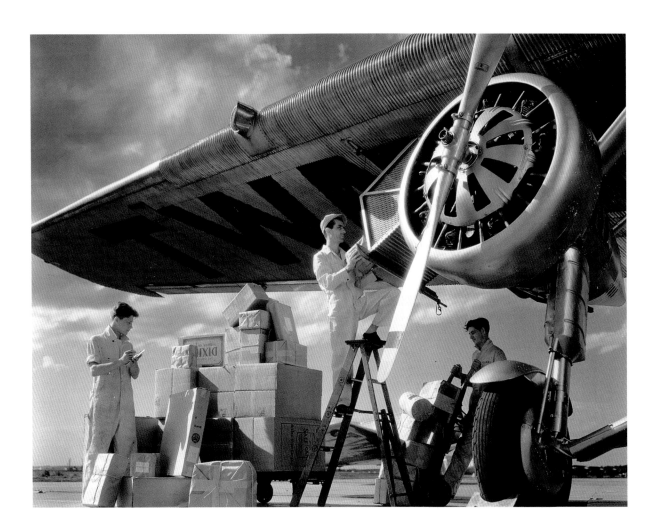

Ocean liner of the sky. A small army of workers walks the *Graf Zeppelin* out of its vast hangar at Friedrichshafen, Germany, home of the Zeppelin company. The control cabin, with its forward-facing row of windows, hangs beneath. Most of the passenger accommodations are within the body of the airship. Extending out from the airship farther back are two of the four engine nacelles.

Named for airship pioneer and company founder Graf (Count) Ferdinand von Zeppelin, the *Graf Zeppelin* began transporting passengers in 1928. At 776 feet long and 100 feet in diameter, it was the largest airship yet built. Its twin sister ships, the *Hindenburg* and *Graf Zeppelin II,* would be even bigger.

To gain publicity and demonstrate the airship's dependability, the *Graf Zeppelin* completed a spectacular circumnavigation of the globe in 1929. From its official start at the naval air station in Lakehurst, New Jersey, the airship flew back to Friedrichshafen, then stopped in Tokyo and Los Angeles before returning to New Jersey. The voyage, which lasted 21 days with 12 days of flying time, had the desired effect. The *Graf Zeppelin* would carry more than 13,000 passengers in comfort and style over Europe, North America, South America, and elsewhere, before the brief airship era ended abruptly at Lakehurst on May 6, 1937.

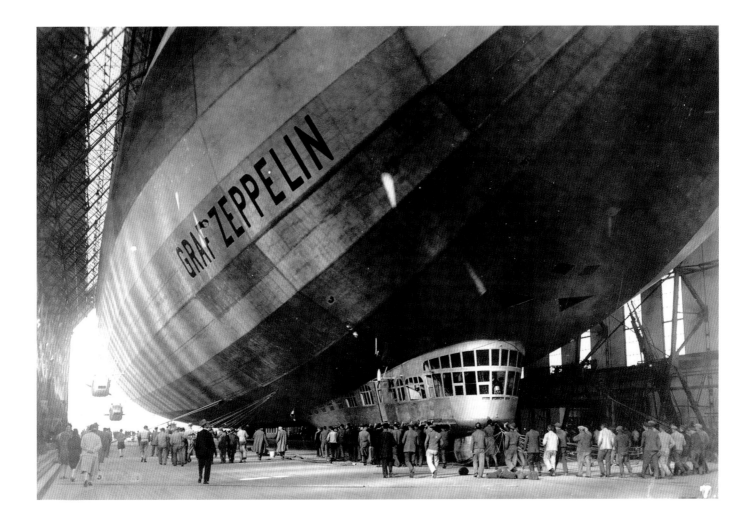

The *Hindenburg's* demise. In 1936, the year before this photo was taken at Lakehurst, New Jersey, F. K. Middleton Hunter described a transatlantic voyage to Germany aboard the *Hindenburg*. After boarding, Hunter recalled, "We suddenly realized that we were under weigh. No commotion, no whistles, no noise…we simply ghosted up into the sky."

The accommodations evoked those of an ocean liner. Hunter recalled that the tiny lower deck contained a shower bath, bar, and smoking room. The middle of the upper deck held 25 "small but comfortable" double staterooms, each equipped with a folding washstand and with upper and lower berths covered by feather comforters. Along the exterior walls were a reading room, lounge (with a miniature grand piano), and dining room. Hunter considered the meals "simple but excellent, and there was a comprehensive wine list." A promenade extended alongside the public rooms and beside the downward facing windows, through which one could leisurely watch the world glide by.

"We neared New York…flying quite low, in fact lower than the top of the Empire State building…. Occasionally the ship dipped or rolled a little, but so majestically that one did not mind it a bit. There was complete absence of vibration, and the motors…could hardly be heard," Hunter wrote. "One had a feeling of complete security."

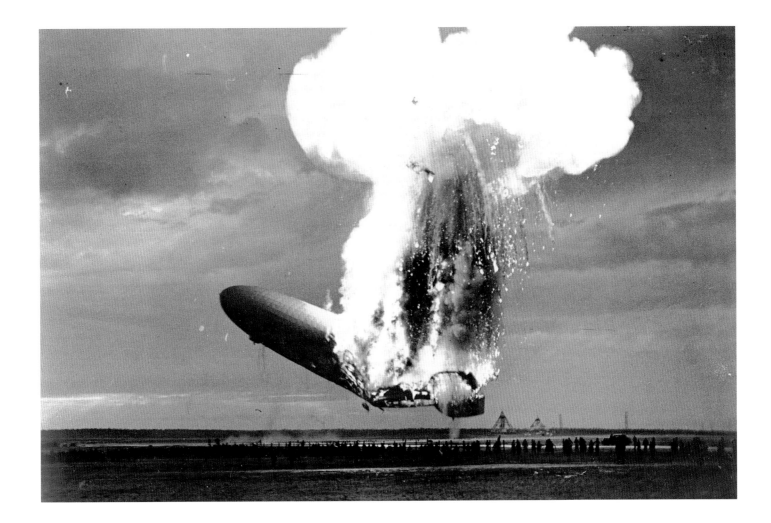

China Clipper completes its epic flight. A flotilla of boats, along with tens of thousands of onlookers, greeted Pan American Airway's *China Clipper* as it docked at its floating landing stage in Manila Bay on November 29, 1935. The arrival of the Martin M-130 flying boat marked the start of the first scheduled transpacific airline service, from San Francisco to the Philippines via Hawaii, Midway Island, Wake Island, and Guam. The seven-man crew had flown more than 8,000 miles in 60 hours over the course of a week.

Newspapers worldwide heralded the achievement. *Time* magazine ran a photo of *Clipper* pilot Ed Musick on its cover. Hollywood was so elated that it came out with a movie the following year called *China Clipper,* starring Pat O'Brien and Humphrey Bogart.

On this trip, the *China Clipper* delivered a cargo of mail, but within a year Pan Am's three M-130s would begin delivering passengers as well. The fortunate few wealthy enough to afford the fare (over $10,000 by today's standards) would enjoy spacious passenger compartments complete with sleeping berths, first-class dining service in a good-sized lounge, and the pleasure of crossing the Pacific in mere days instead of the wave-tossed weeks it took by steamship.

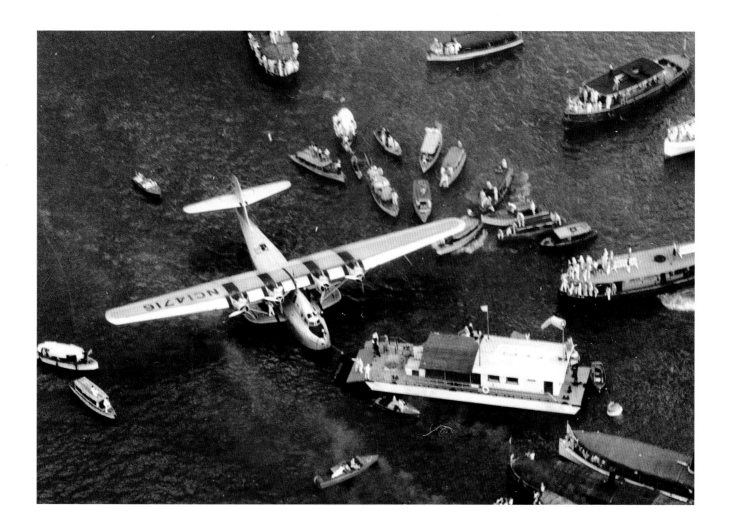

Sailing the skies. A Pan American Airways captain leans back to speak with the flight engineer in the cockpit of their Boeing 307 Stratoliner. A position now largely extinct, the flight engineer monitored the aircraft's four engines and other systems.

Always a trendsetter, Pan American became the first airline to adopt nautical terminology, a nod to the glamorous world of luxury ocean liners. It called its pilots "captains" and its flight attendants "stewards," a practice that soon became almost universal. Crew members wore naval-inspired attire: navy blue uniforms, double-breasted jackets with rank insignia on the sleeve cuffs, white hats. Beginning with its famous flying boats, Pan Am christened its airplanes "Clippers" after the swift clipper ships that once sailed the seas. Not to be outdone, American Airlines named its airliners "Flagships."

Pan Am was America's exclusive international airline until after World War II, when TWA won the right to compete. Pan Am set technological trends too. Its Stratoliner was the first airliner with a pressurized cabin, which allowed the airplane to fly in higher, smoother air. Pan Am debuted the elegant Lockheed Constellation, introduced jetliner service to the United States, and helped shape the Boeing 747 jumbo jet. For a few glorious decades, Pan American ruled the air.

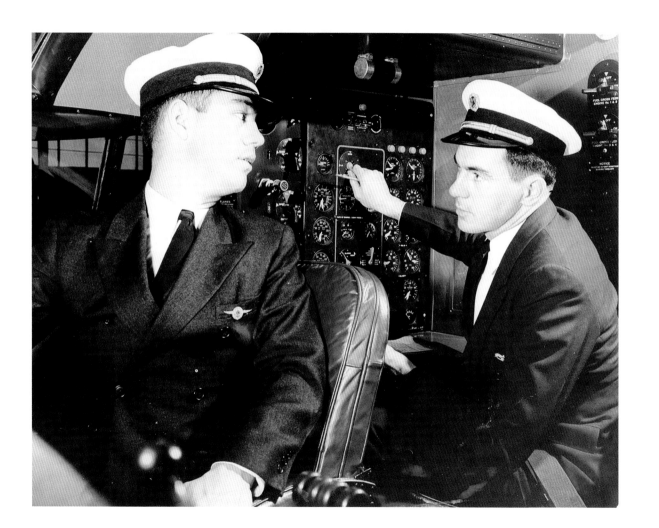

Air travel takes off. The American Airlines Douglas DST *Flagship Massachusetts* is refueled and serviced at Meacham Field, Fort Worth, Texas, in the late 1930s. A DST (Douglas Sleeper Transport) had berths for night travel. The narrow windows for the upper berths can be seen along the top of this Skysleeper's fuselage.

Early airfields were just that—fields. They sufficed for small planes, but as aircraft became larger and heavier, longer paved runways and improved airport facilities were needed. At Meacham Field, all runways had been paved and a new terminal building opened by 1936, the year American began flying Douglas DC-3s. The day-travel version of the DST, the DC-3 was the first airliner that was profitable to fly. Fast, comfortable, reliable, and technologically advanced, DC-3s quickly dominated the nation's airways. Although air travel remained expensive, passenger numbers continued to climb, and with them the need for bigger and better airports.

To help make the new world of air travel feel more familiar, early airport terminals bore a reassuring resemblance to railway stations inside and out. Even the term "terminal" recalls train travel. In the 1930s, new airports began making their own architectural statements with striking modern structures, many in the popular Art Deco style.

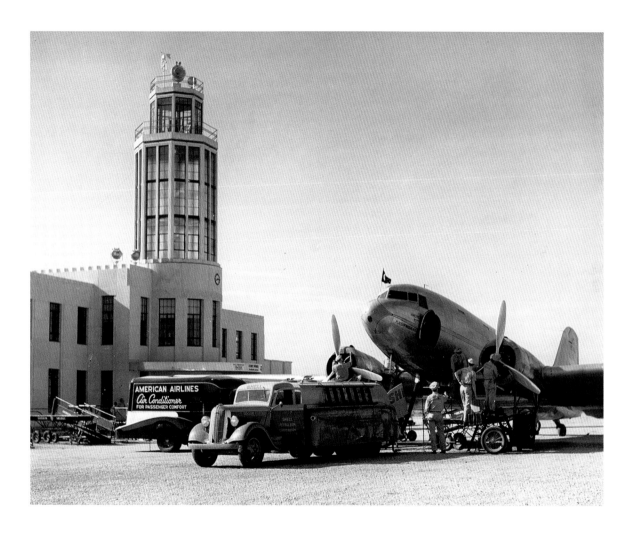

Ancestor of the space suit. Not content to circle the world in less than nine days with navigator Harold Gatty, then solo in less than eight, Wiley Post sought to fly faster by flying higher—in the lighter air of the stratosphere. However, his Lockheed 5C Vega *Winnie Mae* could not be pressurized to allow him to fly that high.

Post decided he needed a pressurized suit, like those that deep-sea divers wore but flexible enough to allow him to pilot a plane. He teamed up with Russell Colley of B.F. Goodrich to invent the world's first practical pressure suit. It had three layers: long underwear, an inner rubber air-pressure bladder (pictured here), and an outer suit made of rubberized parachute fabric along with gloves and boots. An aluminum diver's helmet with a removable plastic faceplate was bolted to the top, and a liquid oxygen canister provided gas for pressurization and breathing.

On the suit's first trial flight in 1934, Post ascended to 40,000 feet. On March 15, 1935, after modifying the *Winnie Mae* for high-altitude flight, he flew from Burbank, California, to Cleveland in record time, reaching a ground speed of 340 miles per hour—almost twice as fast as the *Winnie Mae*'s normal maximum speed—by ascending into the jet stream.

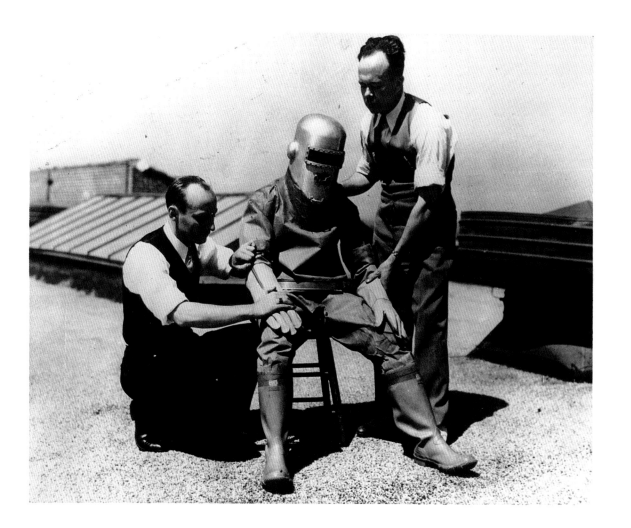

Sikorsky lifts off. Gripping the control stick, with the downdraft from the three-bladed main rotor pressing his trademark fedora against his head, Igor Sikorsky takes his VS-300 helicopter for a limited spin, the craft securely tethered to restraining weights. The pole sticking up above the nose wheel provided a line of reference as he tried to control the craft, which was a bit tricky, to say the least.

The Russian-born engineer and American immigrant began developing helicopters in 1909. However, he soon conceded that the idea was too far ahead of its time. But after three decades designing and building landplanes and seaplanes, he revisited his youthful pursuit. Soon the words *Sikorsky* and *helicopter* would be inseparable.

Taken in November 1939, this image captures Sikorsky's VS-300 in its first configuration. A damaging crash in December prompted a major redesign, with many more alterations to come. In its final form, the VS-300 would be the first successful helicopter with a single main rotor and tail rotor, rather than two counter-rotating rotors. Sikorsky didn't invent the helicopter or the single rotor concept or its control system. But he did mesh them into the first practical helicopter design that launched a whole new field of aviation.

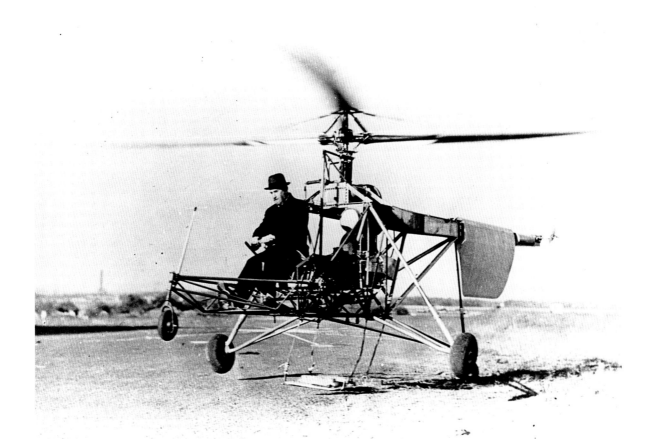

Air mail by Autogiro. Before practical helicopters emerged in the 1940s, Autogiros looked like the future of vertical flight. Their rotors spun freely in flight, producing lift (but not torque), while a propeller provided thrust. They could fly slowly and take off and land in short distances, but they couldn't hover, a crucial advantage of helicopters.

The Post Office used Autogiros for a time to shuttle air mail between airports and post offices in a few cities. The first scheduled service, operated by Eastern Air Lines using this Kellett KD-1B, ran between Camden Airport and the roof of the 30th Street Post Office in Philadelphia for one year in 1939–40. The ten daily flights cut travel time over the 40-some-mile driving distance to six minutes.

John M. Miller, who flew most of those flights, had quite an airman's life. Glenn Curtiss flew near his house when Johnny was four. He soloed in a Jenny on his 18th birthday, watched Lindbergh take off for Paris, made the first cross-country Autogiro flight (two weeks ahead of Amelia Earhart), flight-tested gyroplanes, and piloted airliners from Boeing 247s to Douglas DC-8 jets. In 2005 he flew his Beechcraft Bonanza to celebrate his 100th birthday. "Flying is a youth preservative," he once observed, "if you live through it."

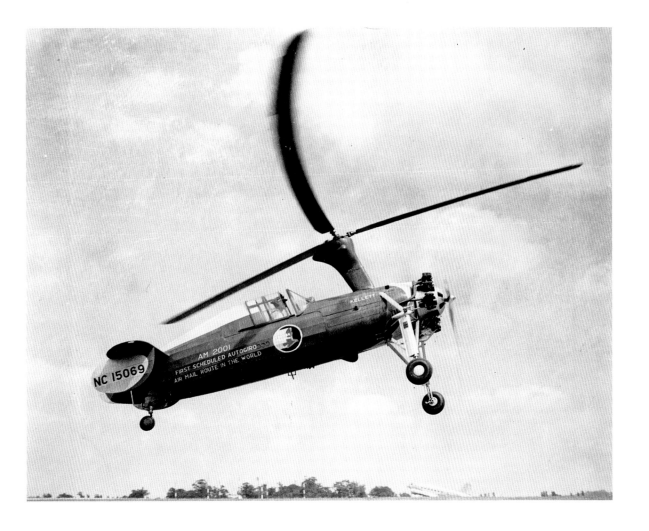

The eyes of Britain. Perched on a London rooftop, an aircraft spotter searches for German planes. After overrunning much of Europe at the start of World War II, the Nazi juggernaut began to focus on the British Isles. To prepare for a planned invasion, Germany launched waves of aerial attacks meant to cripple the Royal Air Force and gain control of the sky. With the first raids on July 10, 1940, the Battle of Britain began.

Air defenses and the aircraft industry were the initial targets, but in early September the Luftwaffe shifted to bombing London, hoping to break British spirit and destroy the resilient RAF in the air, plane by plane. Quite the opposite happened. British resolve stiffened through the weeks of daily bombings, and the shifting of attacks away from air defenses actually gave the RAF a desperately needed chance to regroup.

Throughout the London Blitz, the great domed edifice of St. Paul's Cathedral loomed amid the smoke and flames as a symbol of defiance, escaping major damage while much of the city around it burned. The Blitz climaxed with two massive waves of attacks on September 15, which the RAF repulsed, dealing the Luftwaffe heavy losses. Two days later, Hitler postponed the invasion indefinitely. The bombings would continue, but Germany's only chance to conquer Britain was lost.

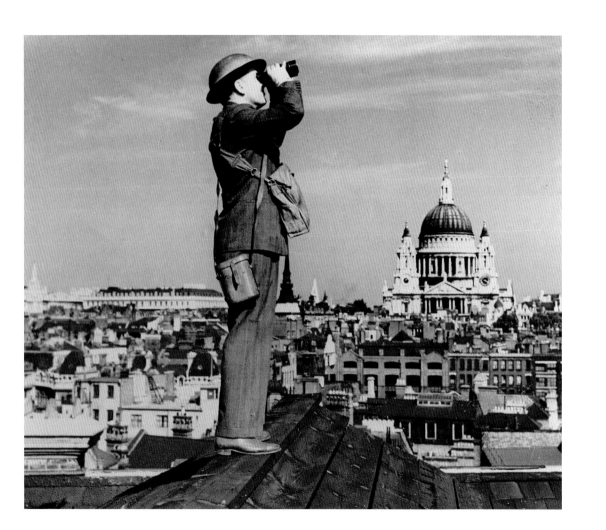

Scramble! With no time to lose, Royal Air Force pilots dash for their Hurricanes to intercept approaching German aircraft. Much of the RAF's success in the Battle of Britain was due to its well-coordinated air defense system. Reports from coastal radar stations and legions of aircraft observers were quickly relayed to a central command, which dispatched aircraft wherever they were needed and made the most efficient use of Britain's badly outnumbered fighter force.

The RAF's Hawker Hurricanes and Supermarine Spitfires, the backbone of the British defense, held their own against the Luftwaffe's much-feared Messerschmitt Bf 109 fighters, but losses were high. Nearly 500 RAF pilots—nearly one in six who fought in the battle—were killed. Not only British pilots fought, but hundreds from other nations—Poland, New Zealand, Canada, Czechoslovakia, and many more.

In a speech to the House of Commons on August 20, 1940, weeks before the Battle of Britain would reach its peak, Prime Minister Winston Churchill immortalized Britain's defenders with the words, "Never in the field of human conflict was so much owed by so many to so few." Those who fought in the battle are still honored in Britain as "The Few."

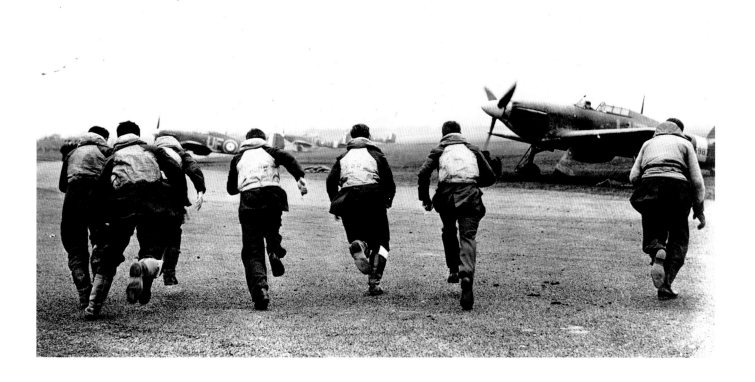

America strikes back. USS *Hornet* crewmen watch an Army Air Forces B-25 Mitchell medium bomber lift off from the carrier deck on April 18, 1942, en route to Japan. Led by renowned aviator Lt. Col. James H. Doolittle, the 16 B-25s bombed military and industrial targets in Tokyo and other cities. The "Doolittle Raid" inflicted relatively minor damage, but it electrified the home front, sharply boosting morale after months of demoralizing defeats after Pearl Harbor.

None of the B-25s reached their intended Chinese landing fields. One detoured to Russia, where its five-man crew was interned. The other crewmen either bailed out or crash-landed in China. Three died in the process and eight were captured. The Japanese executed three and a fourth died in captivity. The other crews found their way back to fight another day. Doolittle was promoted to brigadier general and commanded air forces in North Africa, the Mediterranean, and England.

The *Hornet* survived only six months after its most famous mission. It took part in the crucial Battle of Midway and actions around Guadalcanal. Then, within a few minutes during the Battle of the Santa Cruz Islands on October 26, it suffered a series of devastating hits by torpedoes, bombs, and planes. The burning ship was evacuated, abandoned, and later sunk.

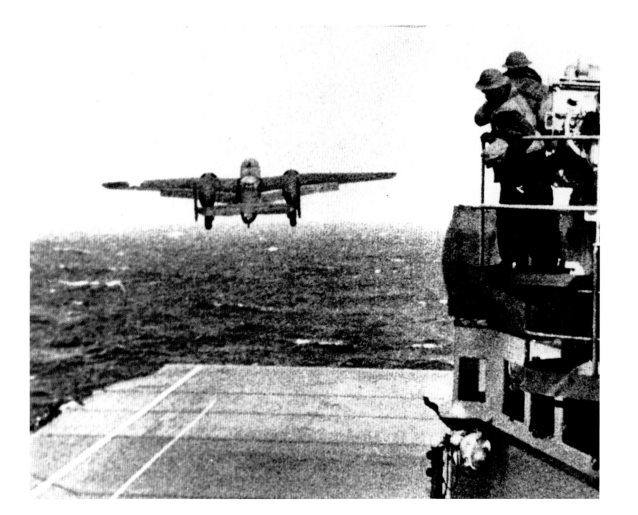

A Wildcat gets the "go." The Grumman F4F Wildcat was the Navy's leading fighter during the first two years of World War II, until more advanced Hellcats and Corsairs began to arrive. Wildcats continued to serve throughout the war, especially on aircraft carriers too small for larger and heavier aircraft. This Wildcat about to launch belongs to fighter squadron VF-6.

World War II saw the aircraft carrier's rise to prominence, especially in the Pacific, where it could deliver air power wherever needed across vast oceanic distances. Carrier aircraft proved decisive in many sea battles, most notably at Midway, where they annihilated the Japanese aircraft carrier force, turning the tide of the Pacific war.

The Navy began experimenting with launchings and landings on ships in 1910, just a few years after the airplane's invention. In 1922 it commissioned its first aircraft carrier, the *Langley,* a converted coal transport. The converted battle cruisers *Lexington* and *Saratoga* followed, then the *Ranger,* the first U.S. ship designed as a carrier from the keel up. By 1944 aircraft carriers were entering service at the rate of about one a month. Battleships still packed a powerful punch, but carriers had become the Navy's most indispensable weapon.

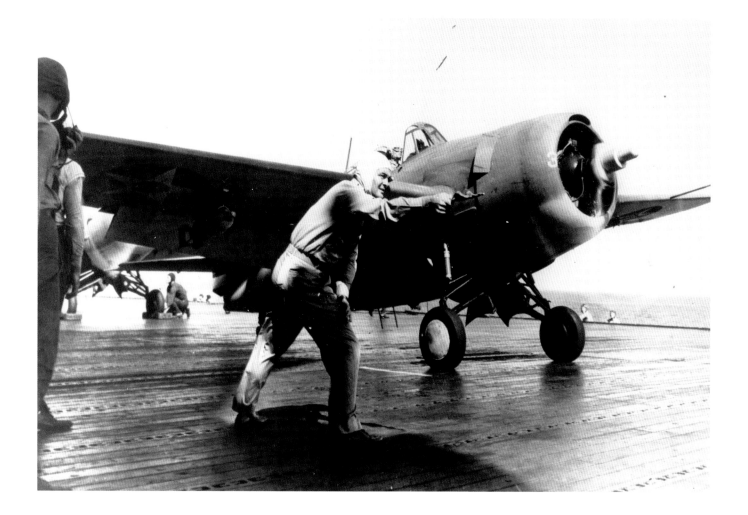

Escort service. Equipped with drop tanks for a long-distance mission, a flight of North American P-51 Mustangs fills the frame. The Mustangs—from top to bottom: *Lou IV*, unnamed, *Sky Bouncer,* and *Suzy-C*—belong to the 375th Fighter Squadron, 361st Fighter Group, Eighth Air Force. Based in England, the squadron accompanied formations of B-17s on bombing missions over Germany.

P-47 Thunderbolts and P-38 Lightnings also served as escorts and could be equipped with drop tanks as well. But Mustangs proved especially suited to the escort role. The delivery of large numbers of them by the fall of 1944 helped stem the horrifying numbers of American bomber losses during the treacherous long-distance daylight raids.

The top three airplanes are P-51Ds, the first model with the distinctive bubble canopy, which improved the pilot's view toward the rear. *Suzy-C,* by contrast, is a P-51B with the earlier canopy design. North American originally designed the P-51 for the British, whose own supercharged Merlin engine so enhanced the aircraft's speed and range that it soon became standard. Also used as a dive bomber, ground attacker, and interceptor, the dashing aircraft earned a reputation as one of the best fighter planes of World War II.

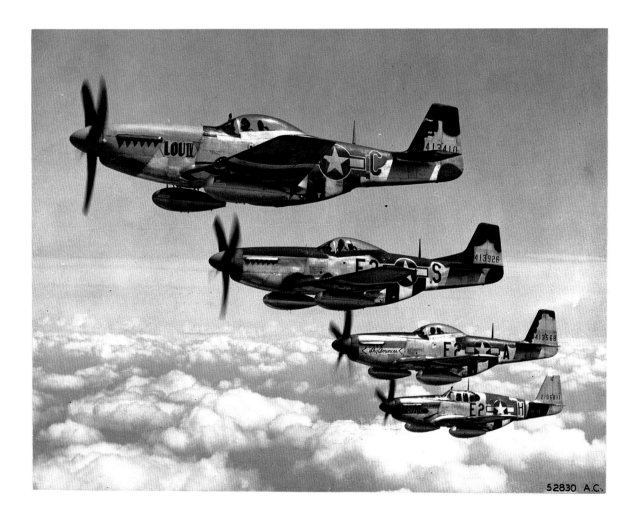

52830 A.C.

One lucky guy. Climbing out of his P-47 Thunderbolt, Francis S. Gabreski had a lot to celebrate: he had just turned 25, scored his 11th aerial victory, and been promoted to lieutenant colonel, all on the same day. Life was good and would get even better, until he pushed his luck a mission too far.

Victory had been elusive. By the time he got into the air at Pearl Harbor, the Japanese were gone. The son of Polish immigrants then talked his way into flying Spitfires in Britain for a Polish unit attached to the RAF, but Gabreski still failed to see much action. Reassigned to the Eighth Air Force, he didn't score his first victory until August 1943; but then, within a year, "Gabby" became America's leading ace.

While awaiting a well-earned plane ride back to the States in July 1944, Gabreski impulsively volunteered to fly "just one more." His plane was damaged during a strafing run, and he crash-landed. The Germans caught him five days later, and he served out the war in a prison camp. But Gabreski went on to claim ace status in jets over Korea as well—not bad for a boy from Oil City, Pennsylvania, who nearly washed out of primary flight training.

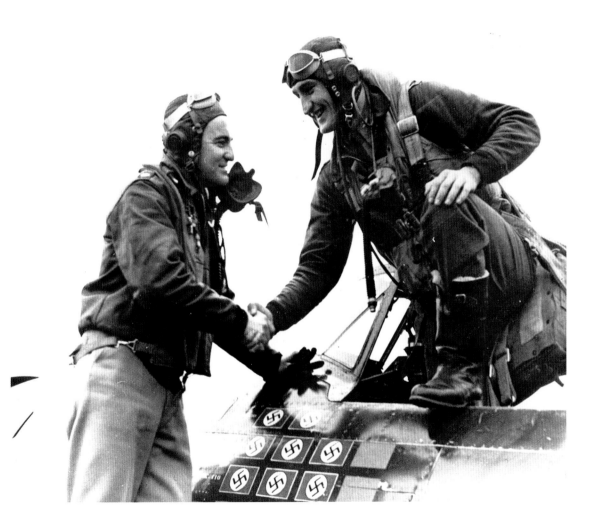

Fireworks. A German ammunition truck disintegrates after being hit by Capt. Raymond Walsh's P-47 Thunderbolt, silhouetted against the blast. This photo was captured by the gun camera of another Thunderbolt, flown by Lt. Wille Whitman. Both pilots made it past the flaming debris and returned home safely to strafe German convoys along the French roads another day.

This ill-fated vehicle was one of about 68,000 destroyed by Thunderbolts from D-Day through VE Day, along with some 6,000 armored vehicles and 93,000 railway cars and locomotives, a toll that severely undermined the German army's fighting ability. Republic Aircraft designed the P-47 to intercept enemy bombers at high altitude, but its speed, agility, and ruggedness made it especially suited to low-altitude combat.

Flyers nicknamed the P-47 the "Jug," perhaps for its milk bottle–shaped fuselage or perhaps short for "Juggernaut," because the thing was so *big*. In fact, it was the largest, heaviest single-engine fighter of World War II. The P-47 also housed the largest, most powerful engine available, the 2,000-horsepower Pratt and Whitney R-2800 radial. Another measure of its success: by war's end, some 15,000 Jugs had been built, more than any other American fighter.

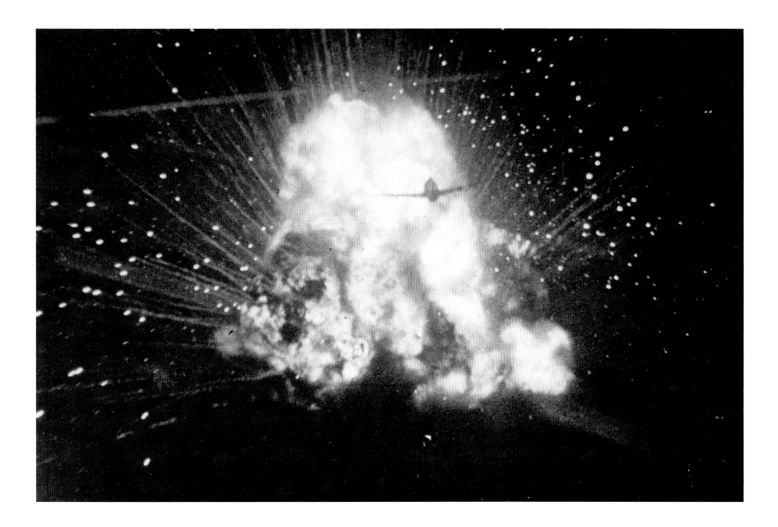

Red tails, black wings. Pilots of the all-black 332nd Fighter Group pose beside one of their red-tailed P-51 Mustangs in Italy in 1944; from left to right: Lt. Dempsey Morgan Jr., Lt. Carroll Woods, Lt. Robert Nelson, Capt. Andrew Turner, and Lt. Clarence "Lucky" Lester.

Graduates of the Army's segregated training program for black pilots at Tuskegee Army Air Field in Alabama, they faced discrimination both at home and overseas. Some white commanders doubted the flyers could master the skills needed for aerial combat. But by war's end, the Tuskegee Airmen destroyed 261 enemy aircraft. The Red Tails left no doubt that they could fly and fight. "Lucky" Lester was a case in point.

Lester earned his nickname "because of all the tight situations from which I had escaped without a scratch or even a bullet hole in my aircraft." But what happened on July 18, 1944, while escorting B-17 bombers was not luck. Intercepted by German Bf 109s, he fired upon one and saw it explode. Dodging debris, he spotted another and attacked. The Messerschmitt went up in smoke, and its pilot bailed out. He pursued and fired upon yet another, which crashed after taking hits—Lucky's third victory in about six minutes.

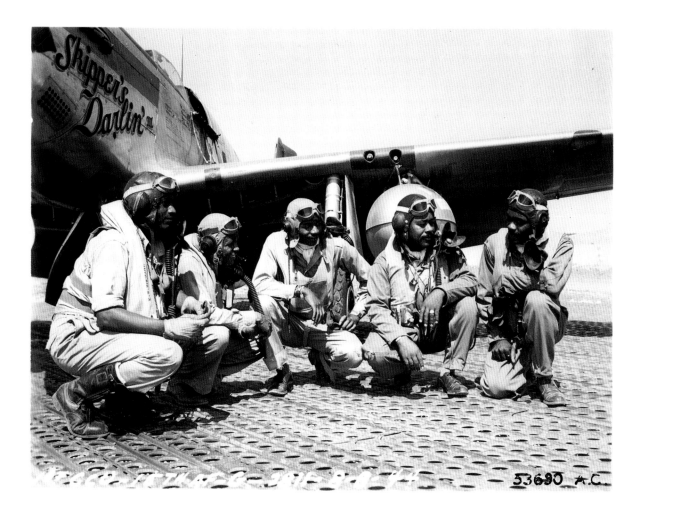

Ploesti. Flak bursts pepper the sky around these B-24 Liberators during a high-level attack on the Concordia Vega oil refinery at Ploesti, Romania, on May 31, 1944. Pillars of smoke rise from hits on storage tanks, a pumping station, and other facilities. Located just north of Bucharest, the vast Ploesti oil complex encompassed seven major refineries, covered 19 square miles, and supplied a third of Germany's oil.

The name Ploesti has become infamously linked with the disastrous low-level raid of August 1, 1943. Although carefully planned, the perilous mission against the heavily defended target was jinxed almost from the start. The lead bomber group lost both of its route navigators along the way, and cloudy weather broke up the bomber groups, which were flying under radio silence. In the chaos of the treetop-level attack and its aftermath, almost a third of the 177 B-24s were lost, along with more than 500 airmen, and another third were heavily damaged.

Eight months passed before another major attack could be mounted. Then, beginning in April 1944, bombers pounded Ploesti repeatedly in high-altitude raids, destroying the oil refineries, but at great cost. Overall, about 500 aircraft were lost and more than 1,000 airmen killed in Ploesti raids.

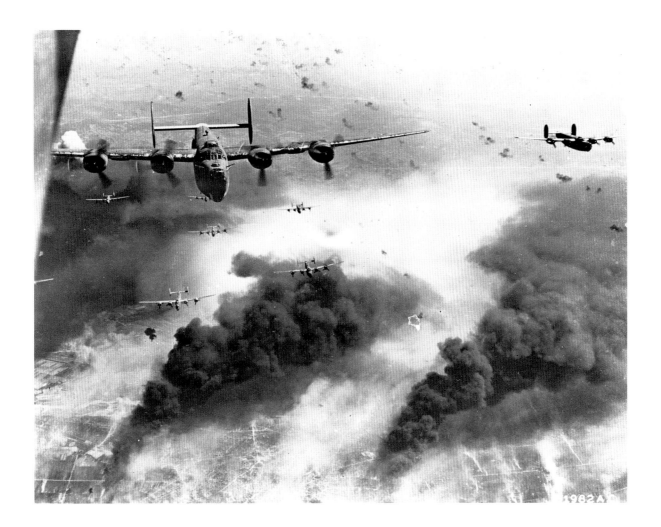

Fortresses in flight. Escort fighters paint the sky with their vapor trails above a squadron of B-17 bombers somewhere over Europe in late 1943. B-17s were the "might" of the "Mighty Eighth Air Force" daylight bombing campaign against Germany in 1943–45, which culminated in massive raids by as many as a thousand bombers.

A journalist who attended the rollout of Boeing's new four-engine bomber in 1935 coined the name "Flying Fortress"—and that was when the aircraft only carried five guns. The B-17 grew into its officially adopted name as Boeing introduced new versions, each more heavily fortified than the last. The ultimate B-17G, with its added chin turret, carried thirteen .50 caliber machine guns and a crew of ten.

Despite the B-17's formidable firepower, bomber losses during daylight missions ranged from heavy to staggering before fighter escort service improved. Of the 12,700 B-17s produced, more than one in three were lost in combat, along with many thousands of airmen. Still, Flying Fortresses earned a reputation for surviving terrible damage: noses blown off, fuselages ripped open, wings shredded, rudders and stabilizers torn off. One, the *All American,* made it home after nearly being cut in two by a collision with a German fighter. After safely landing, it broke apart.

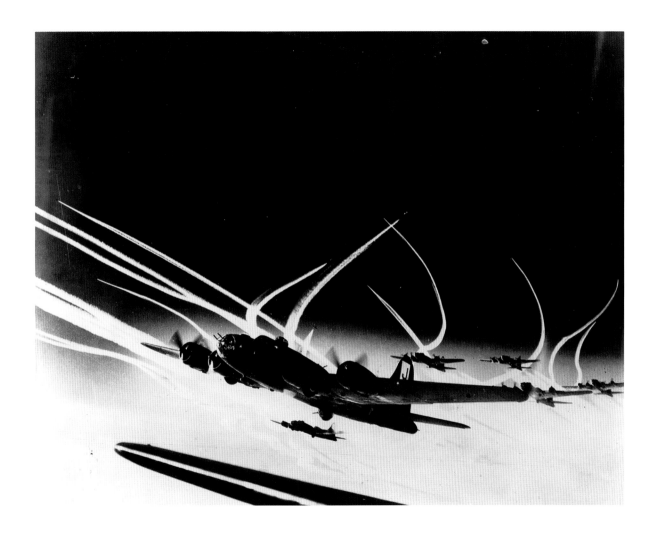

WASPs on the flight line. Women Airforce Service Pilots (left to right) Frances Green, Margaret Kirshner, Ann Waldner, and Blanche Osborn pass a line of B-17s at Lockbourne Army Air Field, near Columbus, Ohio, in 1944. They were among a group of 17 women pilots trained at Lockbourne to fly the big four-engine bombers.

The Women Airforce Service Pilots (WASP) was formed in 1943 from the merging of two women pilot groups attached to the Army Air Forces. The use of women to flight-test new aircraft and ferry them from factories to air bases was quite controversial. But despite resistance from the Army (of which WASPs were not considered members), discrimination, and in some quarters outright hostility, they provided invaluable service, ferrying thousands of aircraft. Thirty-eight WASPs were killed in the line of duty in training or ferrying accidents.

More than a thousand women served in the WASP before the organization was disbanded in late 1944, much to the dismay of most of its members. Not until the late 1970s would the Air Force again allow women in its ranks to fly, and not until 1977 would Congress pass a law officially granting the WASPs military recognition and veteran status.

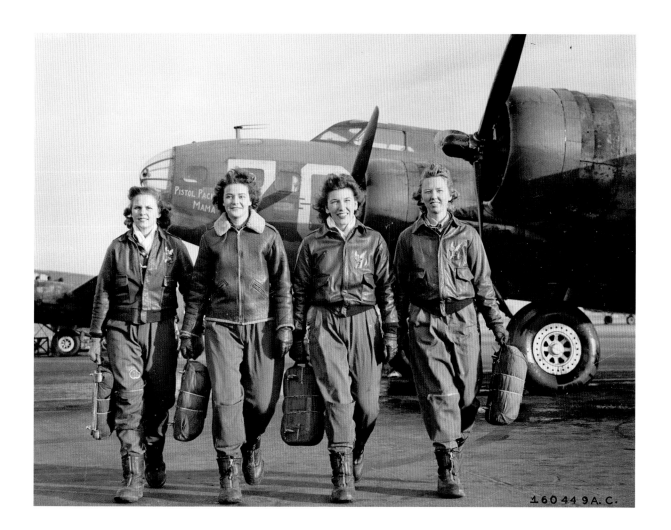

Working to keep them flying. Unsung participants in the air war, two German mechanics work on the nose engine of a Junkers Ju 52/3m. The widely used three-engine airliner served the Luftwaffe as a troop transport and ambulance and was even pressed into service as a bomber.

The mechanics couldn't have had an easy time of it, given how things were going for the Luftwaffe. Not only were they struggling to maintain a dwindling inventory of desperately needed planes, but the airfields and factories where they worked were being bombed relentlessly in Allied air strikes or raked by P-47 Thunderbolts in ground attacks. Germany's air defenses were quickly being decimated, its pilots rapidly falling victim to the bristling guns of the B-17s and the swarms of escort fighters that accompanied them.

At the start of World War II, the German air force—disbanded by the Treaty of Versailles after World War I, secretly re-formed during the interwar years, and officially reestablished in 1935 in defiance of the treaty—was one of the most powerful, advanced, and experienced in the world. But by the time Allied armies stormed ashore in Normandy, the Luftwaffe had effectively been swept from the sky.

A Sea Wolf surrenders. A U.S. Navy airship floats above the captured German submarine U-858, escorted by a Navy warship. When Germany officially surrendered on May 8, 1945, the Allies ordered all U-boats to surface, fly a black flag, and proceed to an Allied port. The crew of U-858 dipped two shower curtains in black paint and hung them on the conning tower. The sub was found by the destroyer escort USS *Pillsbury* south of Newfoundland and boarded on May 10.

U-858 had been on a deadly mission. As Nazi Germany was collapsing, a group of six U-boats called the Sea Wolves were ordered to head for American waters and make a final defiant strike, sinking any ships they could find. Having broken the German message code, the Allies knew they were coming and dispatched a fleet of destroyers and aircraft carriers to the North Atlantic to intercept them. Within nine days they found and sunk four of the U-boats. The destroyer escort USS *Frederick C. Davis* was torpedoed and sunk, the Sea Wolves' only victim.

U-858 was escorted to the waters off Cape May, New Jersey, where this photo may have been taken, for its formal surrender on May 14. It then proceeded to Fort Miles, near Lewes, Delaware, where its ragged young crew was taken into custody. The sixth Sea Wolf surrendered as well, bringing the long and costly Battle of the Atlantic to an end.

Hitler's terror weapon. German propagandists dubbed it Vengeance Weapon 2—a missile that could streak unimpeded though the Ally-controlled skies of Europe and deliver a ton of explosives to a distant city. Unlike the V-1 "buzz bomb," which flew noisily toward its target and could be shot down, the V-2 reached four times the speed of sound during its minute of powered flight. Then its engine shut down, and it arced silently toward its target just four more minutes away. It victims never saw or heard it coming.

Germany produced V-2s at a furious rate, using slave laborers worked to death by the thousands in caverns hollowed out of mountainsides. In the seven months before Germany's surrender, nearly 3,000 V-2s rained down upon England, France, and Belgium. Fired from mobile launchers in Germany or its occupied territories, V-2s indiscriminately killed some 5,000 people and injured many thousands more.

The first long-range ballistic missile, the V-2 would inspire similar programs in the United States and Soviet Union. Both nations would use German technology and technologists to launch both a missile race and a space race.

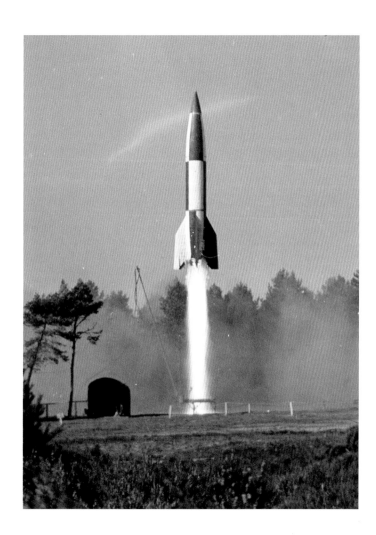

Captive Swallow. Shadowed by a P-38 Lightning, a Messerschmitt Me 262 Schwalbe (Swallow) flies above the Ohio farm country near Wright Field. The first to land in American hands at the end of World War II, this factory-fresh 262 was surrendered by a German test pilot at Rhein Main Airdrome, its rivet lines puttied over in preparation for a camouflage paint job it never received.

Germany outpaced the Allies in developing jet and rocket technology. The Me 262, the world's first operational jet fighter, was one of their most successful efforts. They also built the first jet bomber, a rocket-powered fighter, a jet-powered flying wing, the V-1 flying bomb, and the V-2 ballistic missile. As the Allies overran Germany in 1945, capturing these revolutionary weapons became a top priority.

The Army Air Forces dispatched a team of pilots, mechanics, and engineers under Col. Harold Watson to locate flyable examples of advanced German aircraft and other weapons and to return them stateside for analysis. "Watson's Whizzers" recovered a technological bonanza. And although none had ever flown jets, they ferried many of the aircraft to France for shipment overseas, and then to bases in the United States. Breaking the propeller wings off their AAF insignias, they proclaimed themselves America's first unofficial jet squadron.

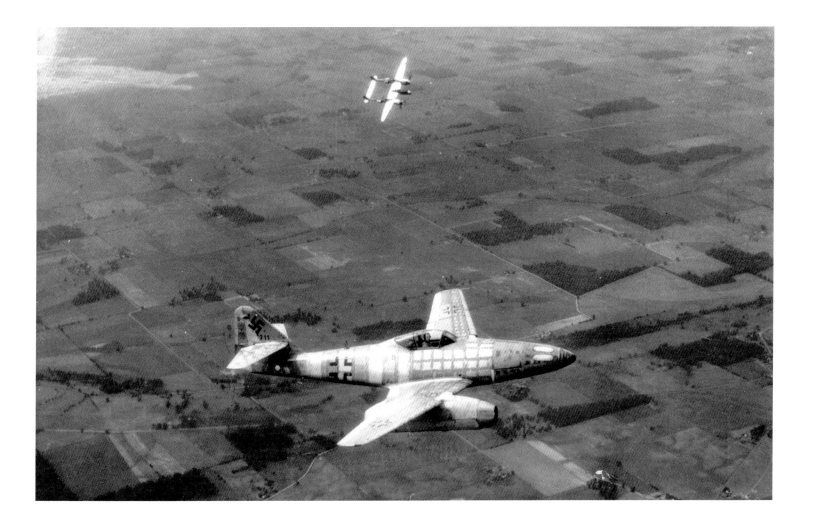

Returning from Hiroshima, August 6, 1945. It was an airplane like so many others that rolled off the wartime assembly lines by the thousands—an advanced bomber for its day, but only one among many of its breed. It never sported the distinctive nose art that adorned many airplanes. Not until the night before its most important mission did it even bear a name. Its pilot, honoring his mother, had painted on one side in bold letters *Enola Gay*.

As it lifted off on that mission, it carried within it a weapon of unprecedented power that would bring both death and deliverance. When the airplane released its heavy load, banked sharply, and turned toward home, history turned with it. By the time its tires touched the earth again, the world had entered a new age.

Now, restored and on display in a Smithsonian museum, it seems almost larger than life, as much an icon as an airplane. After all this time it still evokes intense emotions, from gratitude to grief, its polished surface reflecting back all the feelings and meanings and memories we bring before it.

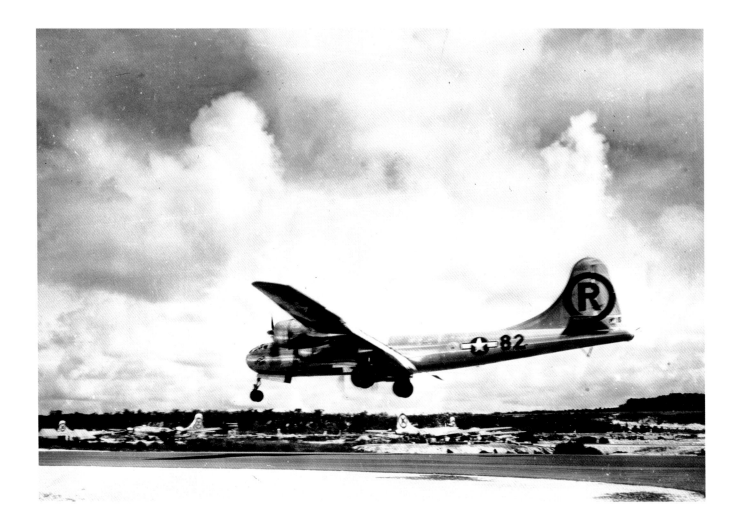

Somewhere in Italy, date unknown. An unidentified soldier stands near a make-shift shelter erected beside a Junkers Ju 88 that has seen its last flight. He might be German or he might be British. The soldier lifts his bugle to his lips. He might be blowing reveille. He may as well be playing Taps.

World War II took a staggering toll in human life: estimates place the number of deaths worldwide at more than 60 million. And unlike the carnage of World War I, in which perhaps 5 percent of the deaths were noncombatants, more than half of those killed in World War II were civilians. Countless millions more were wounded or displaced. Economies were shattered, nations left in ruin.

The use of air power accounted for many of those deaths, both in the air and on the ground. Hundreds of thousands of airmen lost their lives. Entire sections of cities were leveled by the bombing campaigns of both sides. But despite the predictions of prewar military theorists, strategic bombing did not break people's will to fight, let alone single-handedly win the war. But aviation did prove critical throughout the conflict in every theater. In a war that became the watershed event of the 20th century, air power came of age.

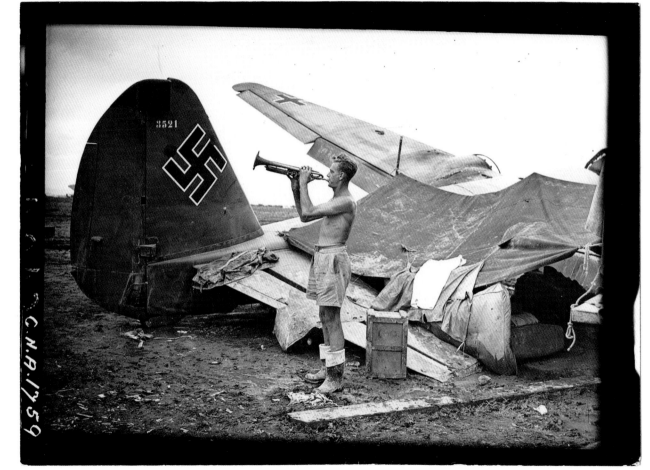

Chalmers, not Chuck. The hero of *The Wright Stuff* wasn't the first or only pilot to fly it, nor was his famous rocket plane the only one of its kind. And officially it was called the XS-1 (for "experimental" and "supersonic," but sounds like "excess"), later shortened to the more succinct, cloak-and-dagger X-1.

Meet test pilot Chalmers "Slick" Goodlin, a handsome guy of 23 who likes to fly fast. In 1941 he was so eager to get into combat that, on his 18th birthday, the American youth joined the Royal Canadian Air Force and soon became its youngest commissioned officer. Goodlin never did get to shoot at Germans. The U.S. Navy lured him back from Britain to train as a test pilot, which was just what Bell Aircraft of Buffalo, New York, was looking for.

Meet the Bell XS-1, one of three similar aircraft, with three more variants built later. Shaped like a .50 caliber machine gun bullet, Bell designed it for one purpose: to puncture the mythical "sound barrier." Goodlin made 26 flights in XS-1s #1 and #2 in 1946–47, before the Air Force took over the project and replaced him with their own pilot, Capt. Charles Yeager. On October 14, 1947, "Chuck" Yeager flew XS-1 #1, which he named *Glamorous Glennis,* past Mach 1 while sitting in the seat warmed by a pilot called "Slick."

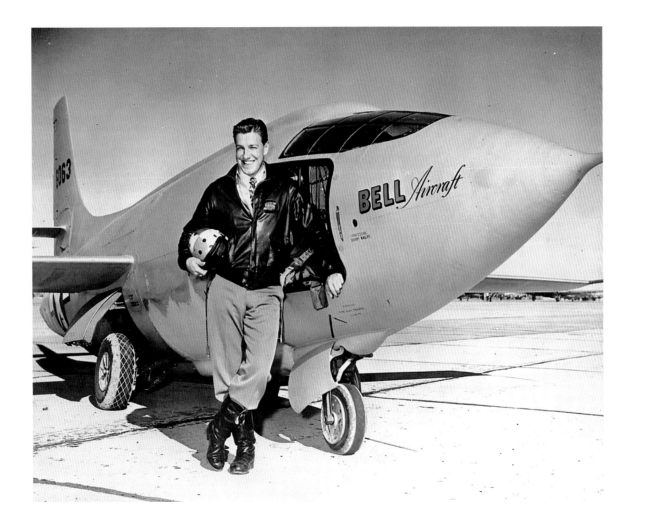

"Operation Vittles." U.S. Air Force C-47 transports line up at Tempelhof Airport in Berlin for unloading during the Berlin Airlift. Located in the Soviet-controlled sector of postwar occupied Germany, Berlin came under siege when the Soviet Union cut off all ground access to the city in June 1948 in hope of gaining total control over the German capital.

The Allies responded with a humanitarian relief effort of unprecedented scale. Within days the United States and Great Britain began flying cargo into Berlin—coal, flour, food, medical supplies, machinery—from air bases in western Germany, while France contributed ground support. At the height of the complex, precisely choreographed operation, aircraft were landing at Tempelhof every three minutes, unloaded within an hour, and sent back for more supplies. The grueling pace continued around the clock and in all weather for weeks, and then months. The lives of more than two million Berliners were at stake.

C-47s (military Douglas DC-3s) carried most of the load until four-engine C-54 Skymasters and R5Ds (Air Force and Navy DC-4s) began arriving from around the world. A Skymaster could transport ten tons of supplies, four times more than a C-47 "Gooney Bird," and could still manage to land on Tempelhof's difficult runways ringed by tall buildings.

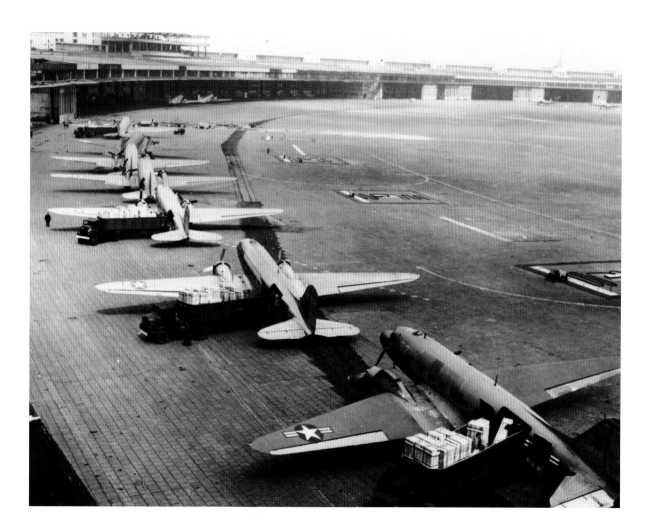

"Airlift Wins!" Flyers of Navy Squadron VR-6 at Rhine-Main Air Force Base, Frankfurt, Germany, welcome the crew of an R5D returning from Berlin on May 12, 1949, the day the Soviet Union finally lifted its blockade of the city. Although the 10-month-long siege was over, the airlift would continue for more than four months to ensure that Berlin had enough supplies in case the blockade resumed.

Before the airlift officially ended on September 30, 1949, the United States and Great Britain flew more than 275,000 flights into the city and delivered millions of tons of supplies to Tempelhof and two other airports. Sixty-five lives were lost carrying out that mission. Air Force pilot Gail Halvorsen won the hearts of many by flying over the city and dropping donated rations of candy and gum attached to handkerchief parachutes. "Operation Little Vittles" caught on and delivered tons of treats to children throughout Berlin.

More than a political and logistical triumph, the Berlin Airlift also served to heal wounds of war on both sides. Airmen who had unleashed devastation onto German cities just a few years before now brought help and hope. They saved the grateful citizens of Berlin from starvation, the chill of winter, and Soviet domination.

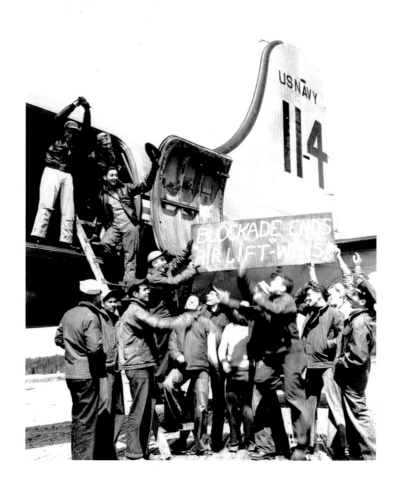

Blue sky, calm waters. Standing on a floating dock behind a substantial pile of gear, a hunter displays a two-goose bounty in this photo taken on a Canadian lake in the 1940s by Hans Groenhoff. A new dimension to the growing resort business in Quebec's Laurentian Highlands, bush pilots could fly hunters and fishermen to places no road could go.

Behind the proud hunter is a Gray Rocks Air Service Noorduyn Norseman V. The floatplane was designed in 1934 specifically for the Canadian market by Robert Noorduyn. An American immigrant from Holland, Noorduyn worked for Fokker, Bellanca, and Pitcairn before striking out on his own to create the Norseman.

Gray Rocks Air Service was started by F. H. "Tom" Wheeler, whose parents opened and ran the Gray Rocks Inn at St-Jovite on Lac Tremblant, one of the region's pioneering resorts. Wheeler and his pilot partner began Laurentian Air Services (as they initially called it) with a single Jenny in 1922, but the demand for their services by Tom's parents' guests quickly grew. In 1924, Gray Rocks received the first commercial aviation license in Canada, and by the 1950s Wheeler Airlines (as it became known) was one of the biggest air services in the Canadian bush. No fish or bird north of Montreal was safe.

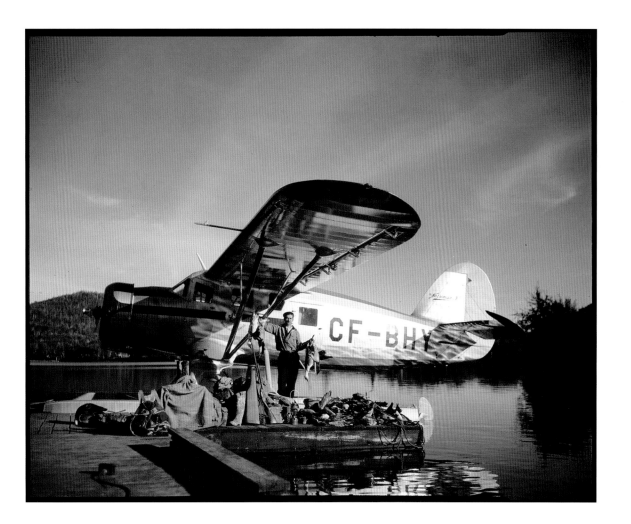

Raring to go. It appears that this youngster can barely contain his eagerness to board the Super Constellation behind him. And who could blame him? In the 1950s, the "Connie" represented the cutting edge of airliner design and performance. For passengers such as these, that meant luxurious, comfortable, and fast.

The famous Lockheed Constellation set a whole new standard for commercial air travel when it appeared in the 1940s. With its gracefully curved fuselage reminiscent of a dolphin and its distinctive triple tail, the Connie was also the most elegant-looking airliner aloft. The first widely used pressurized airliner, it could cruise at "TWA's fair-weather level," as their ads referred to high altitude, as if TWA owned it. The Super Constellation was longer than earlier models and featured larger rectangular windows and better climate control in the passenger cabin.

Until the 1950s, airline travel was mostly limited to wealthy or business travelers—note the briefcase this man is carrying. But powerful, fuel-efficient, long-range aircraft like the Connie enabled airlines to attract less affluent travelers through lower fares. With TWA's Sky Tourist Fares (New York to California for $99), this man could even afford to bring his family along.

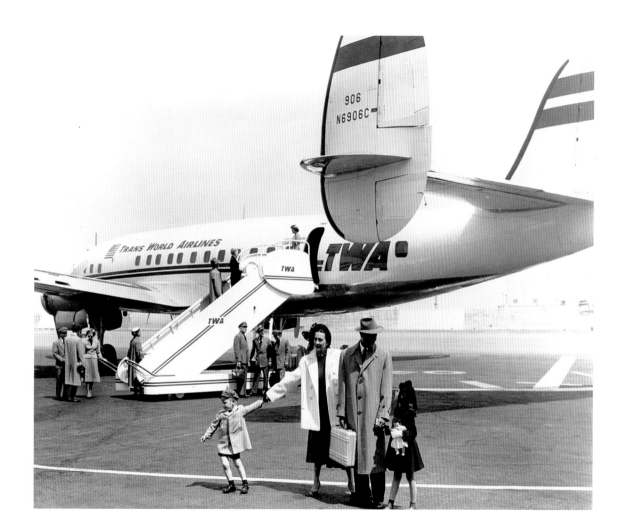

Comfort in the air. A young girl stares back down the aisle past suited men and well-dressed women, awaiting the attention of the smartly attired stewardesses. One stewardess offers food (fresh fruit perhaps?). The other might be taking drink orders. There are curtains on the windows; ash trays in the armrests; pillows, blankets, and fedoras in the overhead racks.

No matter that these "passengers" are probably extras in a United Air Lines publicity photo. The image captures accurately the ambiance of a Douglas DC-6 passenger cabin in the mid-1950s, the golden age of the propeller-driven airliner. The DC-6 was Douglas's answer to Lockheed's revolutionary Constellation in their fierce competition to build a better airliner.

By the end of the 1950s, the drone of whirling propellers would begin to be overtaken by the high-pitched whine of jets. The Boeing 707 and Douglas DC-8 would herald the beginning of a new era in commercial aviation, in which travel would be faster and more affordable.

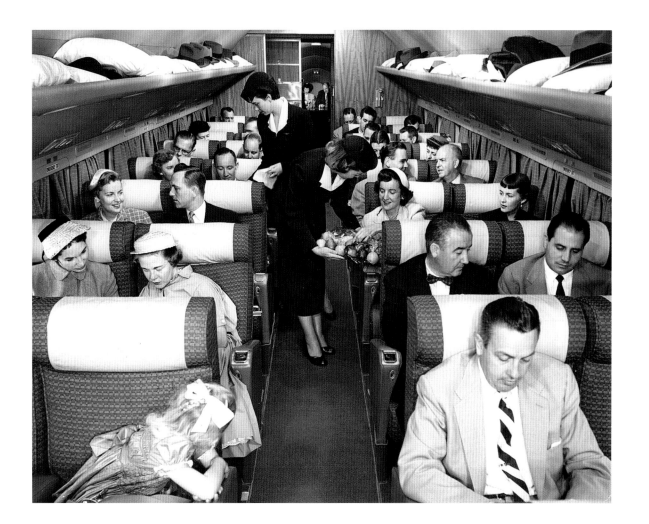

Jet age triumphs and tragedies. On display at Hatfield Airfield in England in August 1949 are two of de Havilland Aircraft's proudest new achievements. The D.H. 106 Comet, soon to become the world's first jet airliner, just made its first flight the month before. The D.H. 108 Swallow, a small, experimental, swept-wing jet plane, helped shape the Comet's design. In 1948 it set a closed-course world speed record and then became the first British aircraft to reach Mach 1.

This Swallow was the third and final one built. All had tragic ends. A few months after the first two prototypes made their first flights, one of them broke apart in midair at Mach 0.9, killing test pilot Geoffrey de Havilland, son of the aircraft company's famous founder. In 1950, within less than three months, the other two 108s crashed, killing their pilots.

The Comet became a sensation when it entered service in 1952. Powered by four jets built into its wings, it cruised at an astounding 480 miles per hour—magnitudes faster than any propeller-driven airplane. Then came the accidents. In the span of less than a year, three Comets crashed, the causes unclear. The entire fleet was grounded. Engineers soon discovered the culprit: metal fatigue. By the time the improved Comet 4 reentered service in 1958, American Boeing 707s and Douglas DC-8s were poised to dominate the jetliner market.

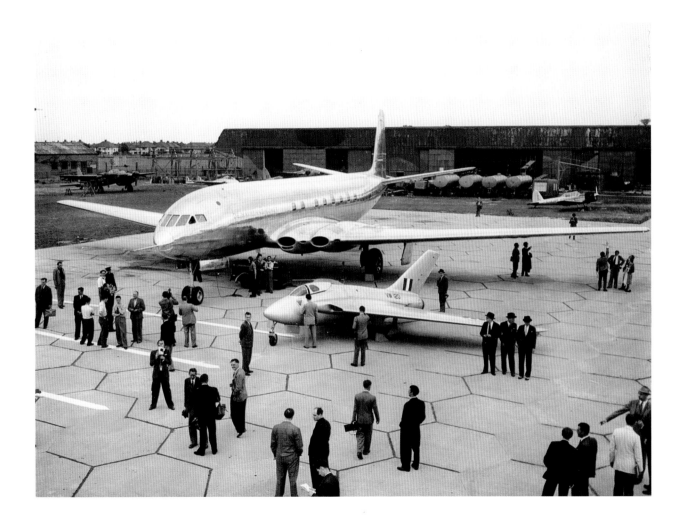

First flight. Pocketbook clutched in one hand, Flying Tiger Line flight bag anchoring the other, she poses before a Douglas C-54 Skymaster that she and her parents soon will board. She may be wondering what all the fuss is about. She will soon find out—her nose smudged against the glass as the world she knows eases away and the airplane dreams upward into a heavenscape of clouds.

Transporting little girls to faraway places was not what Robert Prescott and his fellow veteran fighter pilots had in mind when they pooled their cash, bought some surplus Navy Conestoga transports, and started National Skyway Freight in June 1945. They mainly carried cargo, but passenger charter flights during the '50s helped pay the bills.

The ten pilots, all of whom had flown in China with the American Volunteer Group—the famous Flying Tigers—soon changed their company's name to their advertising slogan, "The Flying Tiger Line," which is what people called them anyhow. The company grew steadily by serving both the civilian and military markets. In 1949 they were granted the first commercial air cargo route in the United States, and thus became the country's first scheduled cargo airline. Four decades later, Flying Tigers merged with the even more successful newcomer Federal Express.

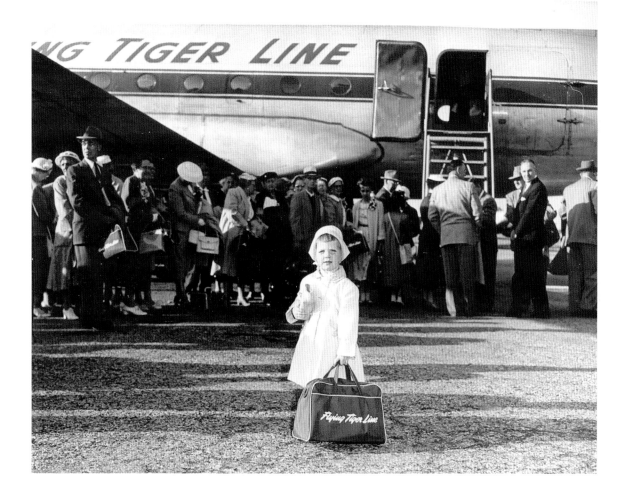

A need for speed. Betty Skelton smiles at the camera, clearly in her element—that is, in the air in the tiniest of aerobatic planes, one that could out–snap roll anything else in the sky. Her Pitts S-1C Special *Little Stinker* (note the skunk aft of the cockpit) redefined what a 1940s aerobatic airplane could do, just as Skelton redefined what a woman could do with an airplane or an automobile.

Skelton grew up around airplanes. While other girls played with dolls, she learned to fly, soloing—quite illegally—at age 12. She earned commercial and flight instructor ratings before she turned 20. Then she discovered aerobatics. Beginning in 1948, she won the International Feminine Aerobatic Championship three times in a row, the last two in her Pitts. Skelton was the first woman to perform what became her signature stunt: the hair-raising inverted ribbon cut, in which she sliced through a ribbon while flying upside down just a precious few feet off the ground.

After quitting aerobatics, Skelton satisfied her thirst for speed with fast boats and faster cars, setting a slew of automotive speed records and female firsts. To show that women were suitable candidates for the ultimate speed trip, she underwent the same physical and psychological testing as America's famous Mercury Seven astronauts—and handily passed.

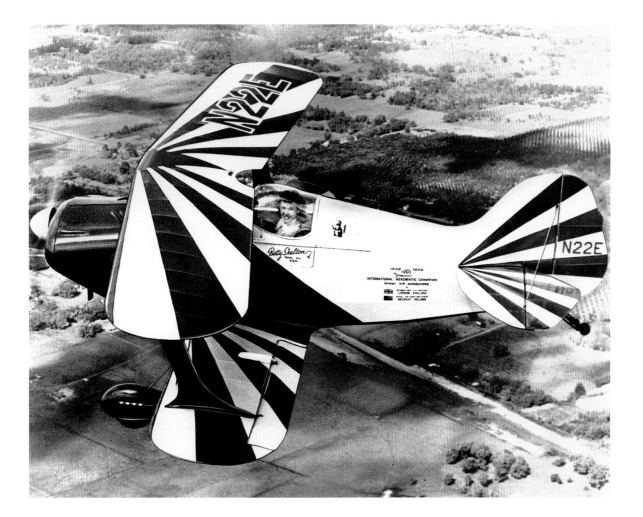

Duster. Using airplanes to spread fertilizers and pesticides on crops began in the 1920s. Crop dusting proved both effective and economical, but a rather hazardous line of work. Pilots flew slow and low—almost brushing the plant tops to minimize drifting of the chemicals—and faced hitting such hard-to-spot obstacles as standing water pipes, fence posts, and electrical wires. The flagmen on the ground who helped guide the pilot faced exposure to toxic chemicals and close passes by the planes.

Dusting was typically done with surplus military trainers: Curtiss Jennys in the '20s, Boeing-Stearman Kaydets in the '30s, Piper Cubs after World War II. In 1950 a research team at Texas A&M created the AG-1, the first aircraft designed for agricultural use. It had a low wing and high cockpit for good visibility, construction materials resistant to chemical corrosion, and safety features to protect the pilot in low-speed crashes. One of the first production aircraft spawned from that design was the Piper PA-25 Pawnee in 1959. The PA-25-260 pictured here was introduced in 1968.

The first aerial crop dusting company, Huff Daland Dusters, founded in Macon, Georgia, in 1924, later broadened with great success into air transportation as Delta Air Service, the forerunner of Delta Air Lines.

Takeoff with an assist. Aided by a booster rocket from a Matador cruise missile, a Republic EF-84G Thunderjet lives up to its name, leaping off its launcher during a "zero-length launch." Photographer Rudy Arnold captured the moment—vehicles and streaks of clouds neatly arrayed around the aircraft—at Edwards Air Force Base in 1955.

The vast, smooth, dry lakebeds within the bounds of Edwards had been used for testing new aircraft and cutting-edge technology since World War II. The Army Air Forces chose the site to test the top-secret Bell XP-59A Airacomet, America's first jet aircraft, because of its isolation, amenable weather, and ample area for emergency landings. In 1951 the Air Force made the base its official flight-test center and moved its test pilot school there.

Edwards has witnessed myriad flight milestones. The Bell X-1 pierced the sound barrier here. The North American X-15s pushed the speed record past Mach 6 and ascended into space. The Lockheed SR-71 and other stealth aircraft became a ghostly presence at Edwards. *Columbia,* the first operational Space Shuttle, landed here after its first controlled descent from space. And even if the old adage "If anything can go wrong, it will" wasn't invented here, it was after an Edwards engineer that Murphy's Law was named.

Nuclear might. A Titan II intercontinental ballistic missile lifts off on a test flight from Cape Kennedy, Florida, headed toward an ocean target near Ascension Island in the South Atlantic. Deployed beginning in 1962, the Titan II was the largest and most powerful ICBM in the U.S. arsenal during the Cold War. It could carry a 9-megaton warhead, and because it used storable liquid propellants, it could be launched from within a missile silo within 60 seconds.

The United States deployed dozens of Titan IIs at silos near Vandenberg, Davis-Monthan, Little Rock, and McConnell Air Force bases. From the 1960s into the 1980s, they served as the backbone of the nation's nuclear missile deterrent force. The Air Force deactivated the Titan II system from 1982 to 1987.

Titan II rockets had other applications as well. In 1965 and '66, they carried all ten pairs of Gemini astronauts into orbit. Other Titan rockets launched planetary spacecraft and military satellites. The Titan family of rockets served for nearly half a century. The final one launched, a Titan IVB carrying a classified intelligence collection payload, lifted off from Vandenberg Air Force Base, California, in 2005.

The new generation of fighters. The transition to jet-powered aircraft accelerated after World War II. The last propeller-driven fighter ordered into production by the U.S. Air Force was North American Aviation's F-82 Twin Mustang, which looked like two of the company's venerable P-51 Mustangs joined at the wing and horizontal stabilizer.

Like their piston-engine predecessors, the first U.S. jet fighters were designed with straight wings, but research showed that swept wings improved speed and performance. North American modified its straight-wing FJ-1 Fury design to produce the Air Force's first swept-wing fighter, the F-86 Sabre. The F-86 dominated the skies during the Korean War. Facing off against Soviet-built MiG-15s, Sabres wracked up a lopsided victory ratio, thanks in large part to the American pilots' superior training and greater combat experience. F-86s flew more sorties and endured fewer losses than any other Air Force fighter during the war.

The F-86 in this circa-1952 photograph is unleashing a barrage of rockets over a target range at Nellis Air Force Base in Nevada. Sabres could carry rockets and bombs in addition to a battery of nose-mounted machine guns.

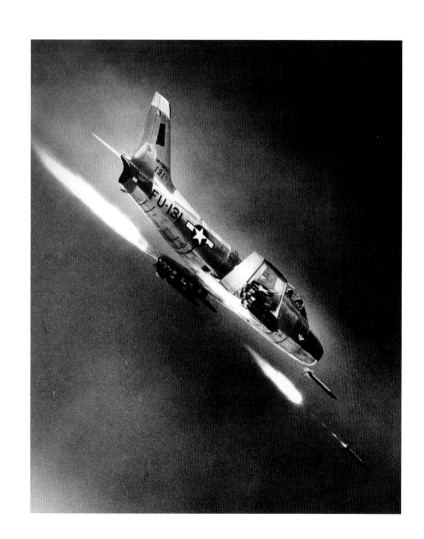

Integration at last. Despite the respect the Tuskegee Airmen had earned during World War II, discriminatory policies toward African Americans persisted after the war ended. Segregation of black units and facilities continued. But the mood in the country was beginning to shift, and a drive toward racial equality was under way.

Even before President Truman issued Executive Order 9981 in 1948, declaring "equality of treatment and opportunity for all persons in the armed services without regard to race, color, religion or national origin," the Air Force had begun to reconsider its position on segregation. Although the order had not set a deadline for integration (or even mentioned the word), change was not long in coming.

A measure of that change was the upsurge in the number of African Americans entering the armed forces, along with the dismantling of what had effectively been a separate black air force. By the Korean War, black pilots and crew members in growing numbers worked alongside whites. In July 1953, eight years after the end of World War II, this integrated Douglas B-26 Invader crew—from left to right: Airman 3rd Class Dennis Judd, Lt. Donald Mansfield, and Lt. Bill Ralston—flew the last combat mission of the war.

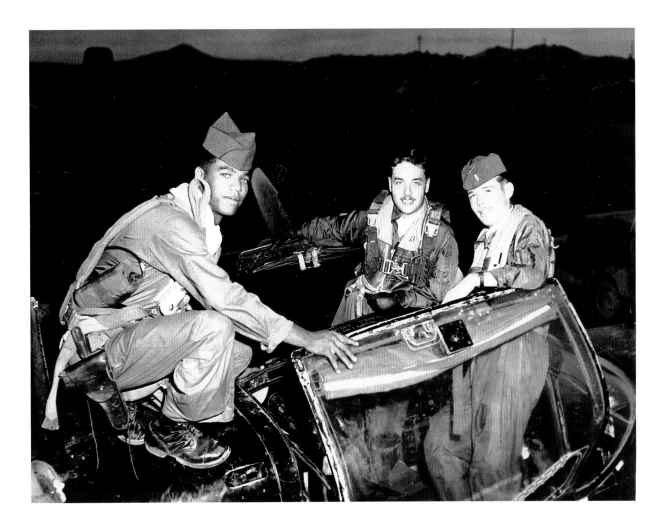

MiGs under maintenance. The arrival of Soviet-piloted Mikoyan-Gurevich MiG-15 interceptors over Korea in 1950 signaled the end of an era for propeller-driven combat aircraft. The swept-wing jet shocked and awed U.S. and U.N. pilots flying World War II vintage Superfortresses, Corsairs, and Mustangs. Although among the finest aircraft of their day, they were no match for the lightning-fast, cannon-armed MiG.

Even the Allies' first-generation straight-wing jets, such as the Lockheed F-80 Shooting Star and Republic Aviation F-84 Thunderjet, paled by comparison in performance. But the newly minted North American F-86 Sabre, rushed to Korea to take back the skies, quickly did just that.

The MiG was entirely a Soviet design, except for the engine. Britain obligingly sold Mikoyan-Gurevich some of its finest Rolls Royce jet engines upon request, which Soviet engineers then reverse-engineered and copied. So eager was the United States to get a hold of an intact MiG-15 that in 1953 it launched Operation Moolah, promising $100,000 and asylum to the first Communist pilot to defect with his MiG. One pilot did so—months after the fighting ceased—but he said he hadn't even known about the reward. He was paid anyhow.

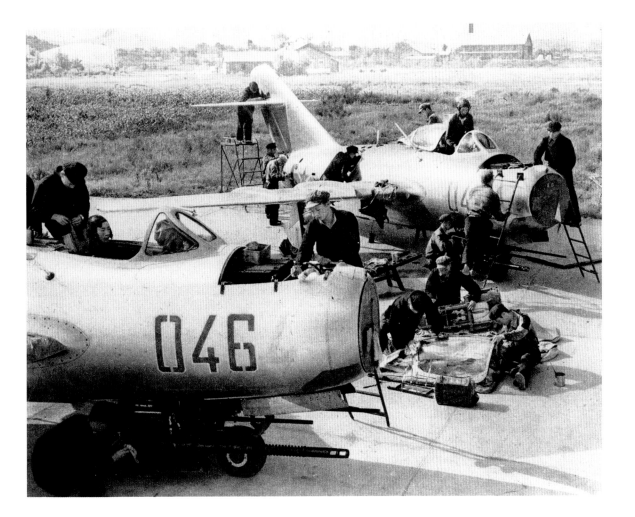

Return of a "MiG Killer." A pilot in flight gear and parachute walks back from the airfield at a base in Korea, a scene captured by Marine Corps aviator Richard Rash. The image is from a collection of color slides taken by Rash that document his tours of duty in China, Korea, and Vietnam. A similar sign he photographed, possibly the flip side of this one, boasts, "Home of the MiG Killers."

MiG Alley is the name Air Force pilots gave to the region in northwestern Korea near the Yalu River, which marked the border between Korea and China. Beginning in 1950 it was the scene of frequent dogfights between U.S. and Communist jets. U.S. rules of engagement forbade pilots from engaging the enemy over China, so the Yalu marked a convenient safe haven for the Communists.

Although the U.S.S.R. never admitted it, a great many of the pilots flying in MiG Alley were Soviet. They proved to be formidable adversaries, far better trained than their Chinese and Korean counterparts. Although American pilots clearly got the better of them, the exact score will never be known. U.S. pilots probably shot down eight MiGs for every Sabre lost in combat.

The helicopter goes to war. Servicemen grapple with a cargo load slung beneath a Marine HRS-1 helicopter during the Korean War. The HRS-1 was the Marine designation for the Sikorsky S-55, which entered service in 1951 just in time for the Korean conflict. It served as a transport helicopter and as an aerial ambulance, although that role was more famously filled by the H-13, which ferried wounded soldiers and Marines from the front lines to Mobile Army Surgical Hospitals, or MASH units.

Helicopters first saw limited military service in World War II. The Army Air Forces used them for light transport work, searching for submarines, rescuing several Allied personnel from the Burma jungle, and evacuating wounded soldiers from the front lines on Luzon in the Philippines.

The Korean War saw far more extensive use of helicopters, although still mainly in the supporting roles of cargo transport, search and rescue, and medical evacuation. The Vietnam War would transform the helicopter into an indispensable combat vehicle for rapidly deploying troops and for supporting ground operations as a gunship—roles that would transform the way battles were fought.

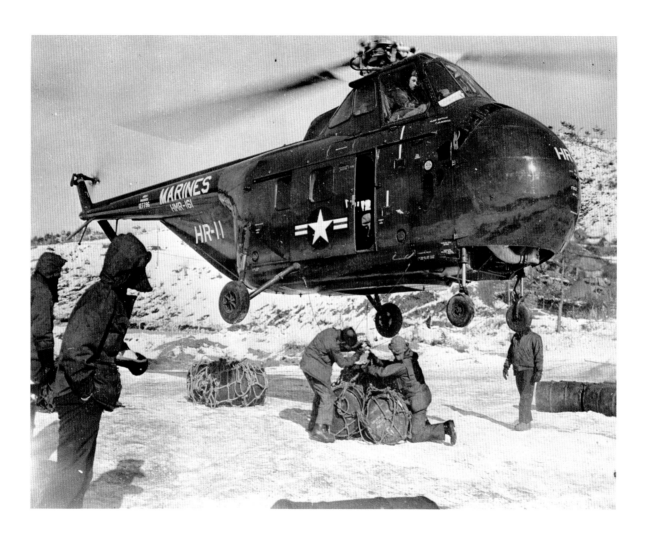

Cold warrior. Gen. Curtis E. LeMay checks out the YB-52, a prototype for the B-52 Stratofortress at Boeing's Seattle plant in 1952. As commander of the U.S. Air Force's Strategic Air Command (SAC), LeMay helped make the B-52 the core of the nation's strategic nuclear bombing force.

LeMay had risen quickly through the ranks with the Eighth Air Force during World War II. Not one to hide behind a desk as a commander, he often led dangerous bombing missions over Europe. His talent for tactics and organization got him transferred to the Pacific to oversee B-29 operations and direct the bombing campaign against Japan. With poor weather hampering high-altitude daylight raids, he ordered the switch to low-altitude nighttime incendiary attacks, which proved devastatingly effective.

After the war he organized the Berlin Airlift, then took command of an inept SAC and transformed it into an efficient force capable of unleashing all-out nuclear war at a moment's notice. He ultimately rose to Air Force Chief of Staff before his retirement in 1965. As an outspoken advocate of strategic bombing and first strikes, he clashed with others on tactics during the Cuban Missile Crisis and in Vietnam. The aggressive hawk was caricatured as Gen. Buck Turgidson by George C. Scott in the 1964 film *Dr. Strangelove*.

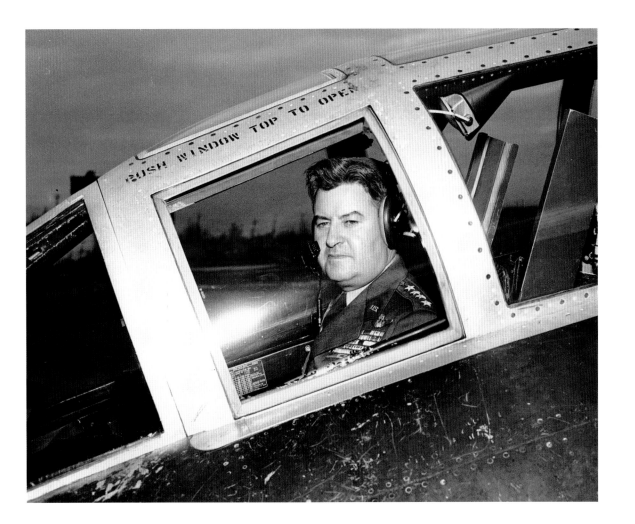

PUSH WINDOW TOP TO OPEN

X-men. These Air Force and NASA test pilots represent half of an elite group: the dozen men that piloted one of the three North American X-15 rocket planes. From left to right: Joe Engle, Robert Rushworth, John McKay, William Knight, Milton Thompson, and William Dana.

The X-15 was among the most successful of the X-planes, a long series of experimental aircraft that began with the sound barrier–smashing Bell X-1. Over the course of 199 flights spanning 1959–68, X-15 pilots repeatedly set new speed and altitude records. They flew as fast as Mach 6.7—4,520 miles per hour—a record never exceeded by an aircraft, and as high as 67 miles, a record finally exceeded in 2004 by SpaceShipOne. Two of the X-15s survive; the other disintegrated in flight, killing pilot Michael Adams.

During 13 flights, eight X-15 pilots achieved the Air Force criterion for spaceflight by exceeding 50 miles in altitude. For that achievement, all the pilots pictured here except Thompson were awarded astronaut wings. (X-15 pilot Joe Walker would twice exceed the more stringent international standard of 100 kilometers/62 miles). Joe Engle later commanded Space Shuttle flights, thus becoming the only pilot to fly two different winged vehicles in space. X-15 pilot Neil Armstrong became the first man to walk on the Moon.

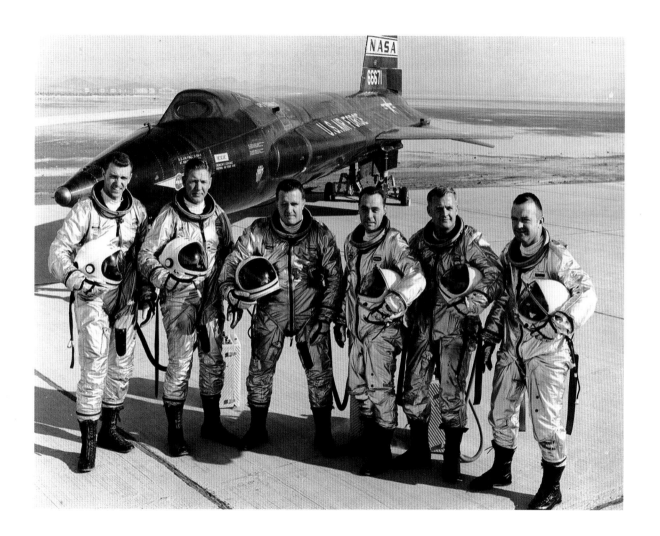

X-plane. As a North American X-15 cools down after a successful flight at Edwards Air Force Base, California, its mother ship and two chase planes roar past in salute. The B-52 carried the X-15 aloft and released it, then the X-plane fired its rocket engine and streaked away. Its skin, made of the chrome-nickel alloy Inconel X, could withstand frictional heat of more than 1,200°F. Small rocket engines in its nose provided attitude control in the rarified high-altitude air where airfoil surfaces no longer worked. The pilot jettisoned the lower part of the ventral fin before landing the aircraft on its two skids and retractable nose wheel.

The Army Air Forces and the National Advisory Committee for Aeronautics (the NACA, forerunner of NASA) began the X-plane program in 1945 to explore the challenges of high-speed flight, from transonic (around Mach 1) to hypersonic (Mach 5 and above). Unlike other test aircraft, the X-planes were intended purely for research, not as prototypes for operational aircraft.

Among the dozens of X-planes flown, the X-15 stands out. Its flight program lasted nearly ten years and made enormous contributions in the areas of aerodynamics, structures and materials, flight control, and piloting techniques for high-speed aircraft and spacecraft.

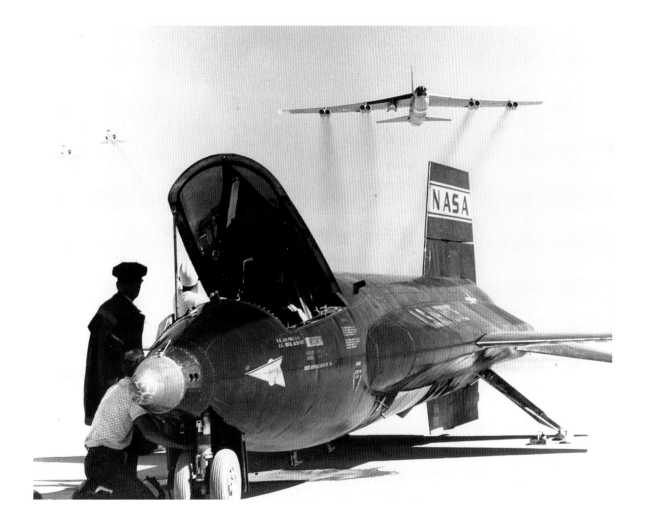

A versatile "chopper." If you've seen the movie or television series *M*A*S*H,* then you've seen a Bell 47 helicopter with its distinctive bubble canopy. This New York City Police Department Bell 47D-1, fitted with pontoon floats, hovers above a pier, while a man clings to a rope ladder hanging beneath it.

Introduced in 1947, the Model 47 was the first helicopter designed for commercial rather than military use. Even so, the military showed a keen interest in its utilitarian design. Army and Marine versions gained fame in the Korean War for evacuating more than 15,000 wounded personnel from combat zones. Civilian versions proved to be just as huge a success. They have been used for police and medical emergency work, fire fighting, traffic reporting, crop spraying, cattle herding, and other wide-ranging roles.

The Bell 47 has some other distinctions. President Dwight D. Eisenhower became the first president to fly in a helicopter in an H-13J Ranger. NASA used Bell 47s to help train Apollo astronauts how to fly lunar landers. The "chop-chop" sound of the 47's two-bladed rotor led to the helicopter nickname "chopper." And New York's Museum of Modern Art was so taken by the craft's elegance that it acquired a Bell 47D-1 for its design collection.

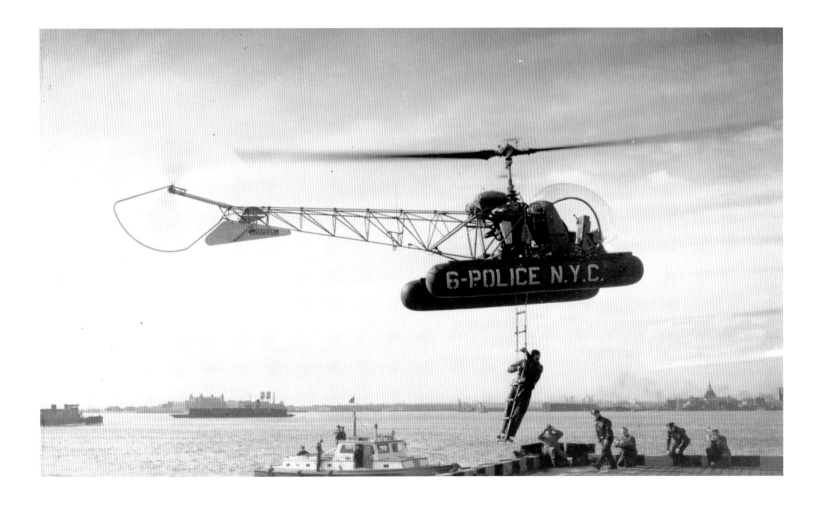

A revolutionary way to fly. The Boeing 707 brought the jet age to American air travelers. Ever the pioneer, Pan American World Airways became the first to introduce 707 service, on its New York to Paris route in October 1958. National Airlines and American Airlines began flying the jet on domestic routes within a few months. United and Delta soon followed suit using the 707's competitor, the new Douglas DC-8. Boeing supplied Braniff with the longer-range 707-227, shown here.

Bigger, more comfortable, and quieter (at least for passengers) than propeller airliners, the 707 was also *fast*—it cut three hours off transcontinental flights. And that inaugural New York–Paris flight (including a refueling stop in Newfoundland) took about half as long as before. Longer-range 707s that could fly nonstop would make the transatlantic trip even faster.

Jet travel quickly became chic among the well-to-do. Members of the "jet set" would jet off to London, Paris, or Rome, or Miami Beach, Bermuda, or Rio, to see and be seen or simply because they could. But they were quickly joined by legions of less affluent flyers, as passenger numbers soared and ticket prices plummeted—a transportation and social revolution made possible by the jet.

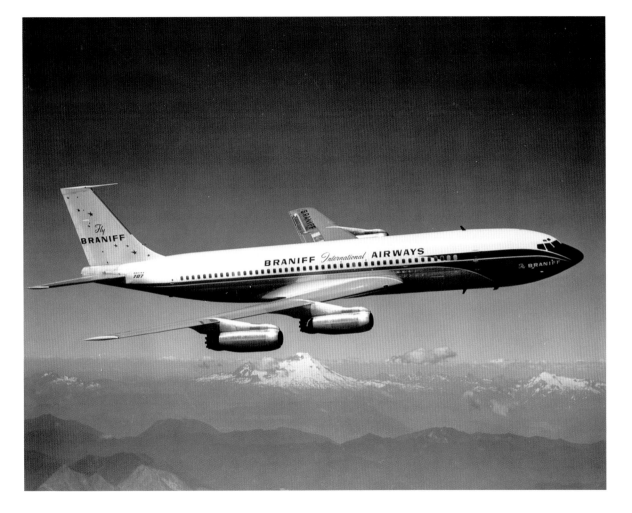

Upholding a Golden Age tradition. American Air Racing's Parker JP001 *Wild Turkey* leads the Prosch PR-2 *Pole Cat* over the high-desert sagebrush of Nevada. This scene is probably from the late 1970s during the Reno National Championship Air Races, the successor to the great air racing spectacles of the 1930s and '40s that helped make Doolittle, Cochran, and Turner household names.

The Cleveland National Air Races, one of the nation's premier racing extravaganzas for two decades, ended after a tragedy-marred event in 1949, when a racer crashed into a home, killing a young mother and her child. The annual event was reborn 15 years later and 2,000 miles west in the Mohave Desert near Reno. Races have been held there each September ever since except in 2001, when all aircraft were grounded because of the 9/11 terrorist attacks.

The races are run on a closed ovoid course marked by pylons, with laps ranging from about three to eight miles. Competing aircraft range from small aerobatic biplanes to the super high-performance Unlimited Class racers, mostly modified World War II fighters. The racers pictured here are Formula One class—custom-built airplanes powered by identical 100-horsepower Continental engines. The fastest can approach 300 miles per hour.

First man in space. On April 12, 1961, Yuri Gagarin became the first person to enter space. During his one orbit in the Vostok 1 spacecraft, he received a field promotion. He rocketed up as a senior lieutenant and parachuted back to Earth as a major, after ejecting from the spherical descent module upon reentry as planned. This photo of him appeared on a Russian postcard.

Gagarin came from a modest background; his parents worked on a collective farm. He learned to fly while in technical school, then entered military flight training. He emerged from a rigorous selection process as a member of the first corps of 20 cosmonauts. Gagarin proved a good fit in many ways. He excelled in training and, at 5 feet, 2 inches tall, took up minimal space in the snug Vostok capsule. His Russian ethnicity and working family background made him an ideal symbol in the eyes of Soviet premier Nikita Khrushchev.

Gagarin's flight instantly made him a Soviet hero and an international celebrity. He continued to work in the Soviet space program and served as backup pilot for the ill-fated Soyuz 1 mission, on which the returning cosmonaut died in a crash landing. But he never returned to space. Gagarin died in a flight accident in 1968 during a routine training mission, while requalifying as a MiG-15 pilot.

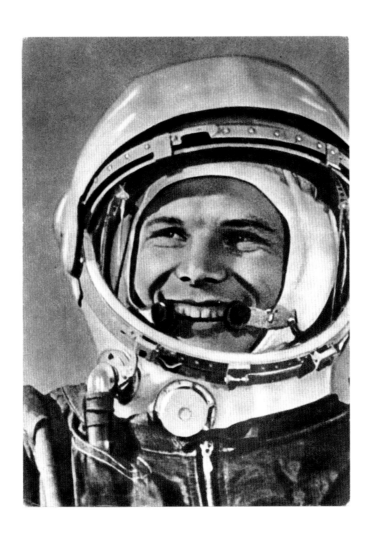

All conditions "Go." At 5:20 a.m. on May 5, 1961, Alan B. Shepard Jr. squeezed into the *Freedom 7* Mercury capsule, attached the oxygen hose to his suit, checked the straps securing him to his form-fitting couch, and tried to relax as he waited to make history. He noticed on the control panel a note that fellow astronaut John Glenn had left for him: "No Handball Playing in This Area."

Minutes after this photo was taken, the hatch door was sealed. More than three long hours and a few final glitches later, Shepard's Redstone rocket roared to life, and the Navy pilot became the first American astronaut in space. His suborbital flight lasted just over 15 busy minutes, as he monitored spacecraft systems and flight events, tested the manual controls, and observed the stunning spectacle of the Earth from space.

Shepard's wait to return to space would be long. His second Mercury mission was canceled, an ear disorder grounded him during Project Gemini, and he swapped for a later Apollo mission, trading away a flight on Apollo 13. But as commander of Apollo 14, America's first spacefarer became one of the select few—and the only Mercury astronaut—to walk on the Moon.

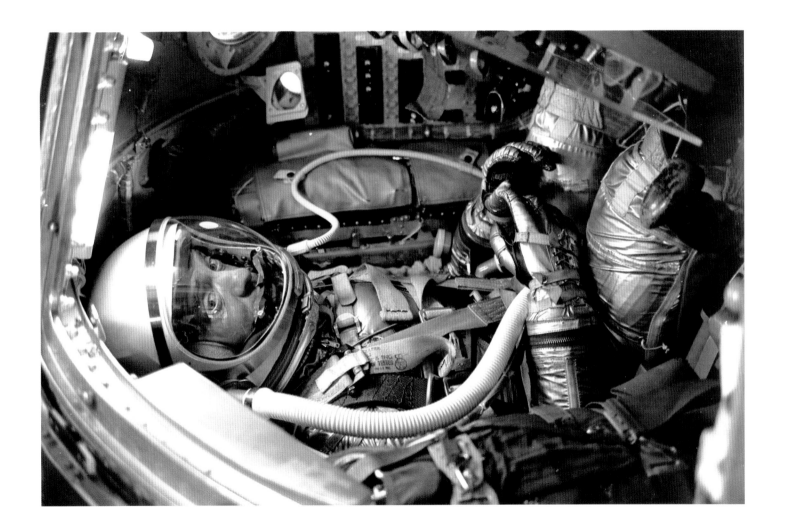

The next American hero. NASA selected Marine Lt. Col. John H. Glenn Jr. for the third Mercury mission, the first to send an astronaut into orbit. Senior in age and rank among the Mercury Seven, Glenn brought to the project both a distinguished service record and a winning smile. As a test pilot and a decorated combat veteran of World War II and Korea, he possessed the nerves of steel required for the unnerving prospect of being strapped inside a capsule atop an Atlas rocket and fired into space.

It required saintly patience as well, for the countdown to launch first began on January 27, 1962, but Glenn didn't reach T minus zero until 24 days later. Along the way, the launch was scrubbed four times due to adverse weather conditions and delayed numerous times for technical reasons, including three holds during the final 45-minute countdown.

But at 9:43 a.m. on February 20, the main engines on the Atlas finally fired up, and seconds later John Glenn lifted off in the capsule he had named *Friendship 7*. Glenn had a five-hour ride and three Earth orbits ahead of him, but at that moment he must have been happy just to be off the ground.

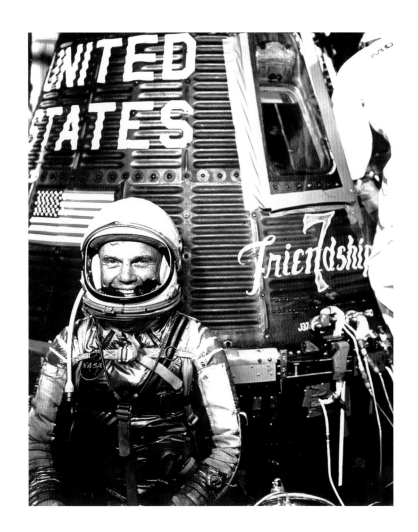

Hoisting *Friendship 7* from the ocean. John Glenn must have been even more relieved when his Mercury capsule splashed down in the Atlantic near the southeastern end of the Bahamas, just a few miles from his recovery ship, the U.S. Navy destroyer *Noa*. The flight had gone according to plan except for two significant glitches, one quite unsettling.

First, an attitude control jet clogged while in orbit, throwing off the automatic control system. Glenn switched to manual control and expertly corrected the problem. Then, an instrument light at Mission Control warned that the spacecraft's heat shield might be loose—a potentially catastrophic situation if true. NASA decided not to jettison the capsule's retrorocket package as planned, but instead keep it strapped over the heat shield to help hold the critical protective shield in place during reentry.

The problem turned out to be a faulty switch in the ground control console, not the heat shield. A sonic boom alerted *Noa*'s crew to *Friendship 7*'s reentry, and they spotted the capsule drifting down beneath its main parachute. Within minutes after splashdown, *Noa* was alongside and sailors were lifting *Friendship 7* aboard with John Glenn safe inside.

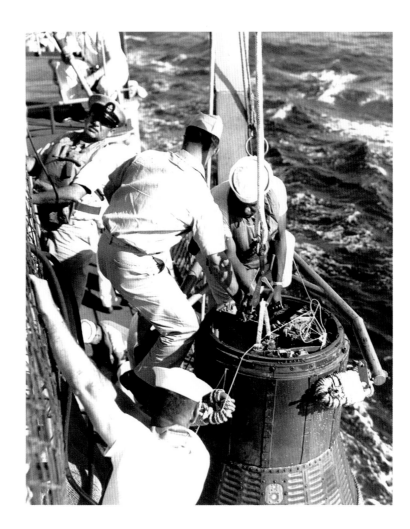

A stroll in space. Edward H. White II floats outside the open hatch of Gemini IV, connected to the spacecraft and its life-support systems by an umbilical line and tether wrapped together in gold tape. Sunlight glints off his gold-tinted faceplate, designed to protect him from the intense solar rays. He fires the thruster in his right hand to maneuver and move as far as 25 feet from his spacecraft.

James A. McDivitt took this picture of his Gemini IV partner on June 3, 1965, the first day of their four-day flight, by far the longest U.S. space mission yet. White spent about 20 minutes "walking" in space, the first American and the second person ever to enter that void. He soon used up his thruster's 20-second supply of compressed oxygen fuel, took a few photographs, and enjoyed the dazzling view of the Pacific Ocean and the southwestern United States.

As Gemini IV passed over Mission Control in Houston, flight director Chris Kraft ordered White inside, but McDivitt had to coax the reluctant astronaut into the spacecraft. "This is fun," White protested. He finally complied and climbed back inside, lamenting to McDivitt, "It's the saddest moment of my life."

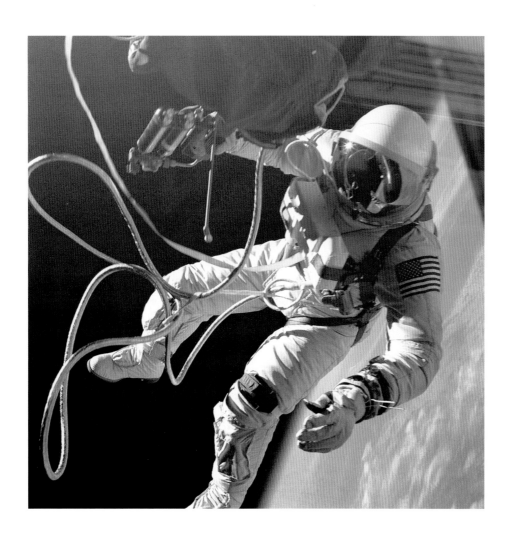

The big picture. 1968: The Communist Tet offensive broke out across South Vietnam. An embattled President Lyndon Johnson declined to run for reelection. An assassin murdered Rev. Martin Luther King in Memphis. Race riots raged in U.S. cities. An assassin murdered Sen. Robert Kennedy in Los Angeles. Violence erupted between police and antiwar demonstrators in Chicago.

Yet as this turbulent year drew toward its end, humanity bore witness to an extraordinary and uplifting event. For the first time, three men had truly "slipped the surly bonds of earth" and gone into orbit around the Moon. While emerging from the far side, they saw a sight no one had ever seen before: the planet Earth rising over the lunar horizon.

Frank Borman, James Lovell, and William Anders of Apollo 8 became the first to ride the Saturn V rocket and the first to leave Earth orbit. They held countless millions around the world spellbound as they read from the Book of Genesis on Christmas Eve, while sending back live TV images of the barren lunar surface passing below them. But this picture of an Earthrise, "the most beautiful, heart-catching sight of my life," Borman wrote, symbolizes what may be their most momentous legacy: showing us our world from afar, a unique oasis in the blackness of space, gleaming with color and life.

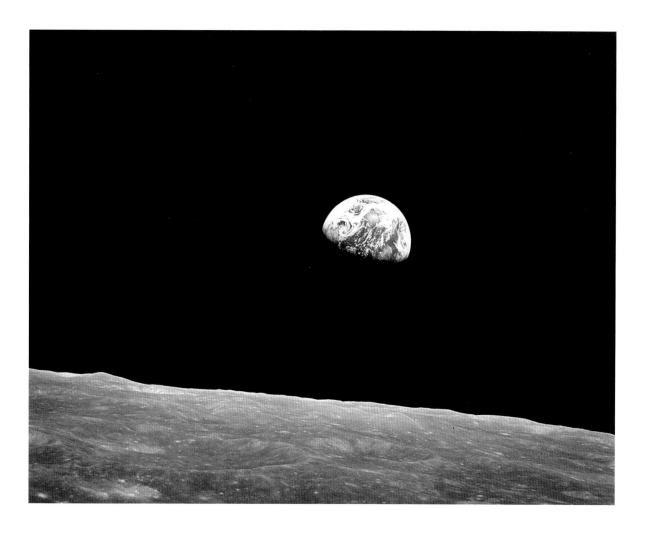

Man on the Moon. You can see reflected in Buzz Aldrin's face plate his shadow blackening the lunar surface, Neil Armstrong taking his picture, the gold-foiled legs of their lunar module. Behind Aldrin the horizon breaks sharp and near. Pressed into the powdery soil around him are footprints no wind will ever erase.

If you are old enough to remember, you know where you were at the time, on July 20, 1969. Most likely in front of a television, maybe a black-and-white set. The whole world was watching. In eastern America it was getting late. But this was human history in the making, and you stayed up to watch. The *Eagle* landed in the Sea of Tranquility at 4:18 p.m. Eastern time, but it wasn't until 10:56 that Armstrong eased down the lunar module's ladder. Then one small step and there he was, standing on the Moon. You felt yourself letting go of a long-held breath.

Bounding about on the stark terrain, the astronauts in their white suits looked eerily like ghosts, as if you could see right through them. Their voices crackled with static. The dust they kicked up settled slowly. If you were someplace where you could see the Moon, you probably gazed at it for a while. Maybe you even gave a little wave, knowing that, for the first time in all time, someone was walking around up there who might wave back.

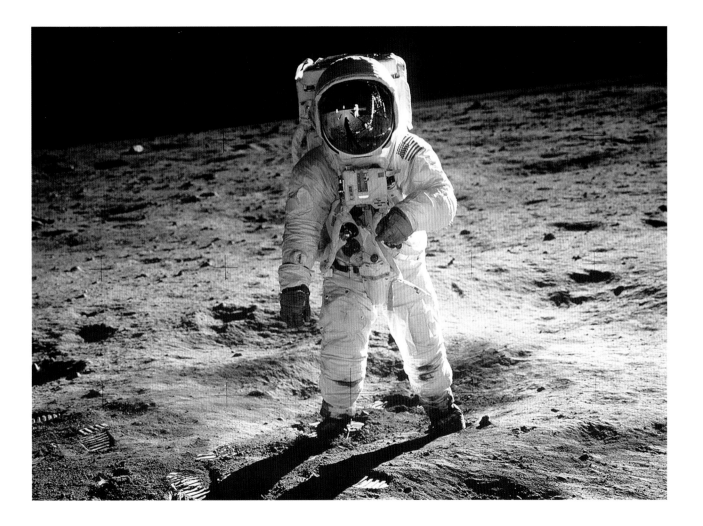

Just in case. President Richard Nixon congratulates Apollo 11 crew members Neil Armstrong, Michael Collins, and Buzz Aldrin (left to right) aboard the aircraft carrier *Hornet* after their return from the first lunar landing mission. They are isolated within a Mobile Quarantine Facility (MQF) to prevent them from infecting Earth with "Moon germs."

NASA took the possibility of extraterrestrial pathogens deadly seriously. When the astronauts opened their capsule's hatch after splashdown, divers handed them Biological Isolation Garments to wear, which were then scrubbed down with disinfectant. Once on the *Hornet,* the three men went directly into the MQF, where they resided along with a NASA doctor and a technician for 65 hours while the entire unit was flown to Houston. There the five men moved into a more spacious facility for the remainder of their 21-day quarantine.

The MQF was a modified 1969 Airstream Trailer welded to a pallet. It could house six people for ten days and, while snug, was certainly far cushier than the astronauts' accommodations in space. Negative pressure and other precautions kept any potential "bugs" inside. The Apollo 12 and 14 crews also stayed in MQFs. By Apollo 15, NASA was confident that Moon microbes were no threat, so the quarantines were abolished.

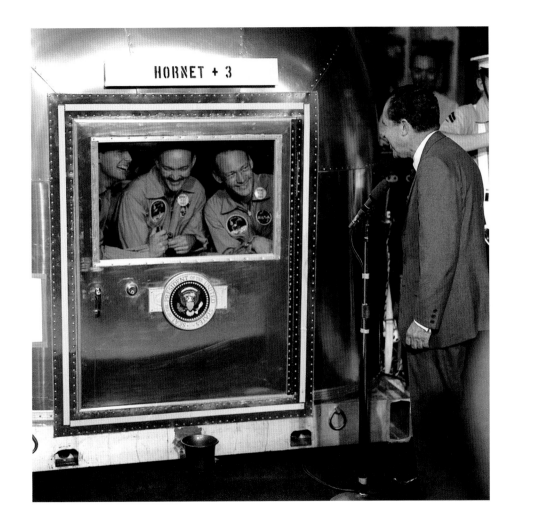

Night light. On December 7, 1972, at 2:33 a.m., night turns to day at the Kennedy Space Center, as the Saturn V rocket of Apollo 17 ignites and rises past its gantry. Well over a half-million spectators have gathered to witness the only Apollo launch to take place at night. The ground trembles beneath them. The deafening roar and the blinding light overwhelm their senses. As the rocket thunders upward and arcs out over the Atlantic, its fiery glow brightens the sky from North Carolina to Cuba.

The three-stage Saturn V is the largest, most powerful rocket ever launched. It stands as tall as a 36-story building. Its cluster of five first-stage engines, each titanic in size, burn liquid oxygen and kerosene to unleash 7½ million pounds of thrust.

An amazing feat of engineering, the Saturn V made the lunar landing flights possible. It always succeeded in delivering its payload into space and boosting its crew toward the Moon. The crew it carries on this flight, Eugene Cernan, Ronald Evans, and Harrison Schmitt, will be the last it sends beyond Earth orbit. As darkness heals the night and the thunderous echoes fade, the final visitors to the Moon for many decades are on their way.

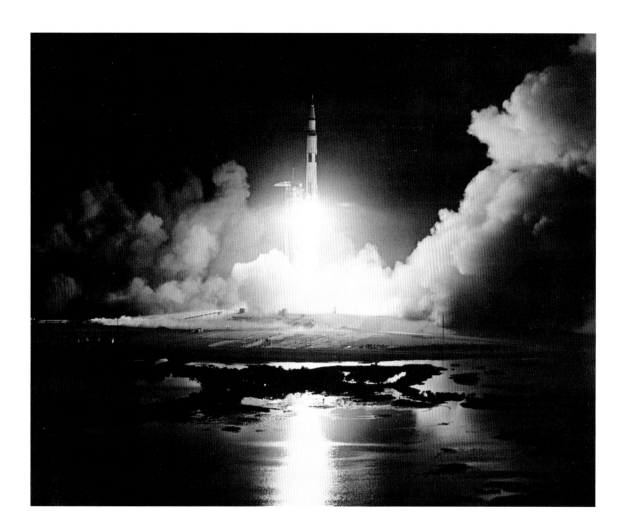

Wishing upon a star. By the late 1950s, several government-funded groups were working to develop satellites that could relay communication signals across the globe. But a privately funded effort called Telstar—short for "telecommunications star"—became the first sensational success.

Telstar was created by AT&T's Bell Laboratories, the people who gave us transistors, lasers, and myriad other wonders. The satellite was covered with panels of solar cells (another Bell invention) and had two belts of small windows around its middle, through which it received and transmitted microwave signals. AT&T, which at the time *was* the phone company, envisioned a whole constellation of Telstars in the heavens that would revolutionize how the world communicated. NASA launched Telstar 1 into space on July 10, 1962.

Telstar astonished the world during its brief life, relaying television pictures, telephone calls, faxes, and data. It sent the first live TV signal across the Atlantic, which included part of a Phillies-Cubs baseball game while operators awaited a prearranged broadcast by President Kennedy. But AT&T's dream faded when the United States put its money behind government-created COMSAT and Intelsat. Now inert, Telstar 1 still orbits the Earth with countless other satellites that have abundantly fulfilled its promise.

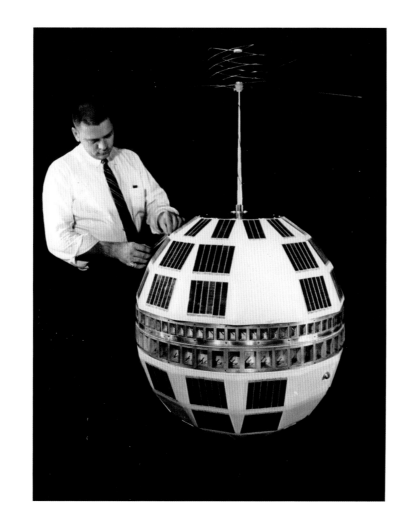

Dawn of the jumbo jet. The sharp increase in air travel brought on by the advent of the passenger jet soon led to a new breed of big wide-body airliners. The first and largest of these was Boeing's 747, which Pan Am began flying in early 1970. Powered by four gigantic turbofan engines designed expressly for it, the 747 in its various versions could carry 400 to 500 passengers 5,000 to upwards of 7,000 miles nonstop. The 747 would remain the largest airliner in service for more than three and half decades.

Aside from being huge—Boeing had to create a brand-new assembly plant more spacious than any building ever built—the 747's most distinctive feature was its topside hump containing an upper deck. The second deck was initially used as a passenger lounge, then for premium seating. Boeing extended the top deck on later 747 models.

The airplane pictured here is the 747SP *Clipper Constitution*. The SP, which stood for "special performance," was shorter and could fly farther than the original 747. Boeing designed it for ultra-long-range routes and to compete with the tri-jet Douglas DC-10 and Lockheed L-1011, as Boeing had no comparable midsize wide-body models. Pan Am again flew it first, in 1976. But unlike standard 747s, the SP never really caught on. Fewer than four dozen were built.

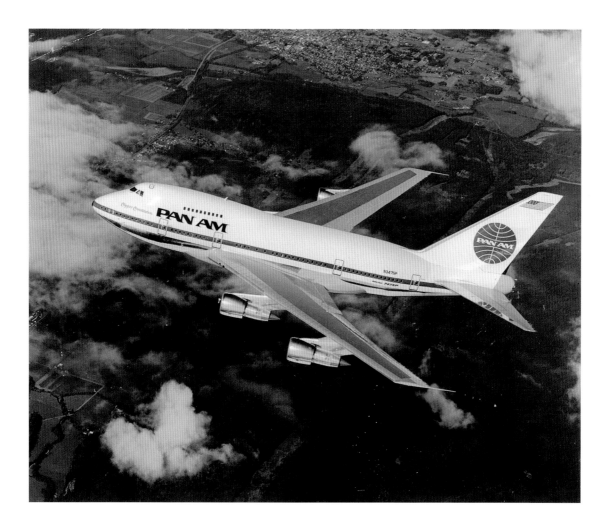

Showing their colors. These flight attendants (probably from China Airlines) certainly make a distinctive style statement. They model a colorful, interchangeable ensemble of blouses, jackets, skirts, and shoes, with white gloves providing a final elegant touch. This circa 1970 photo reflects the emphasis airlines were placing on fashion, as well as the evolving image of the flight attendant.

Before 1930, cabin crews consisted of male stewards, a title reflecting the nautical terminology airlines had adopted. But that year, a young woman with a dream to fly convinced Boeing Air Transport that having a female registered nurse aboard would reassure fearful flyers; thus, Ellen Church became the first "stewardess."

Ensuring passenger safety was always the main role of flight attendants, but in the 1960s they became marketing tools as well. With airfares regulated, airlines tried to compete for passengers—most of whom were male businessmen—by offering such amenities as attractive young stewardesses. Uniforms grew colorful and skirts shorter, and uniforms from the eye-catching to the outlandish appeared. Once airfares were deregulated in 1978, low prices, rather than pretty legs, sold tickets. Uniforms returned to more conservative styles, much to the relief of more than a few flight attendants.

In a class of its own. A Boeing B-52 Stratofortress unleashes its bomb load over Vietnam in 1966. Although used extensively in Southeast Asia for conventional bombing, the long-range heavy bomber was originally designed to carry out— or, more hopefully, to deter—nuclear war. Throughout the Cold War, fully armed B-52s of the Strategic Air Command remained on ground alert, ready for takeoff at a moment's notice. For a time many flew on airborne alert within easy range of the Soviet Union.

Boeing produced 744 B-52s from 1952 to 1962. Nearly half were destroyed under the terms of the 1991 Strategic Arms Reduction Treaty. Yet more than half a century after their introduction—rebuilt and upgraded with newer engines and advanced technology and weapons systems—dozens remain in service, having outlived many of their successors.

Economical, effective, and versatile, the eight-engine bomber can carry up to 60,000 pounds of ordnance, and with mid-air refueling it has virtually unlimited range. During the 1991 Persian Gulf War, B-52s flew 35 hours nonstop to Iraq and back from their Louisiana base, the longest aerial strike mission in history. They served in Afghanistan and Iraq in the 21st century, and the U.S. Air Force plans to use them for decades to come.

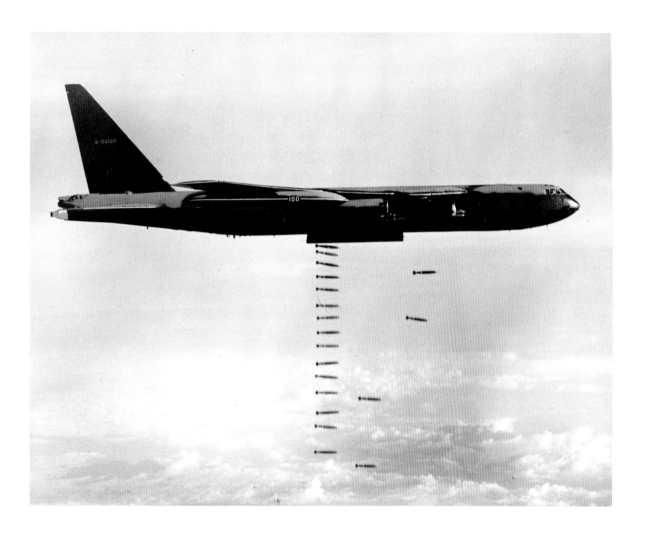

Air mobility. Helicopters had proven their worth for rescue and medical evacuation in Korea, but in Vietnam they reshaped how the ground war was fought. Because of them, a new kind of tactic emerged—using helicopters to rush troops into and out of combat zones, often taking the enemy by surprise. Air mobility made the notion of a static battlefront obsolete, as ground forces could be deployed quickly wherever and whenever they were needed.

The mainstay of the air mobility strategy was the U.S. Army's Bell UH-1, formally named the Iroquois, formerly known as the HU-1, and universally called the Huey. Its distinctive appearance, the unmistakable "whop-whop" sound of its rotor, and its ubiquitous use throughout the conflict by all the U.S. military services made the Huey as enduring a symbol of the Vietnam War as the Jeep was to World War II.

The helicopter's Achilles heel was its vulnerability to ground fire. Hundreds were shot down with great loss of life. But Hueys also played a huge role in saving lives by rapidly airlifting tens of thousands of battlefield casualties to medical facilities, thus increasing their chances for survival. Lt. Col. S. F. Watson, a U.S. Army helicopter pilot, captured this iconic scene of a Huey above a forest clearing.

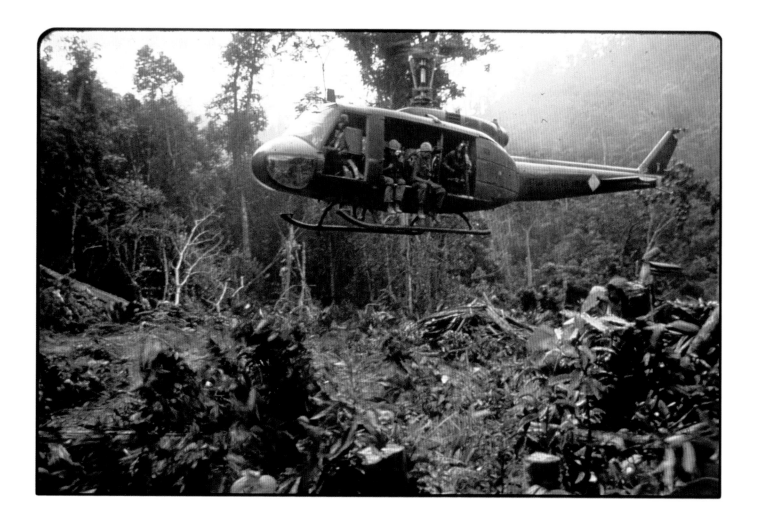

Return of the Phantom. What the Huey was to the ground war in Vietnam, the McDonnell F-4 Phantom II was to the air war. Although the Phantom was designed to be the Navy's first Mach 2–capable carrier-based fighter, most F-4s were flown by the Air Force. This Navy Phantom belonged to squadron VF-31 and flew off the USS *Saratoga*.

The F-4 was a distant relative of the original Phantom—the straight-wing McDonnell FH-1, the Navy's and Marine Corps' first jet fighter. Other carrier fighters had long since superseded the FH-1, but McDonnell resurrected its name when two other choices, Satan and Mithras, were wisely rejected. To show off the new aircraft's capabilities, Navy Phantom pilots set a string of speed and climb-to-altitude records, some of which remained unbroken for many years.

F-4s proved very successful. What they lacked in agility they made up for with sheer thrust and firepower and unmatched versatility. They could put on a good show too—the Navy Blue Angels and Air Force Thunderbirds both switched to Phantoms. For a late-1950s design, the F-4 had an extraordinary service life. The Navy retired its last one in 1986. The Air Force flew them off into the wild blue yonder for another ten years.

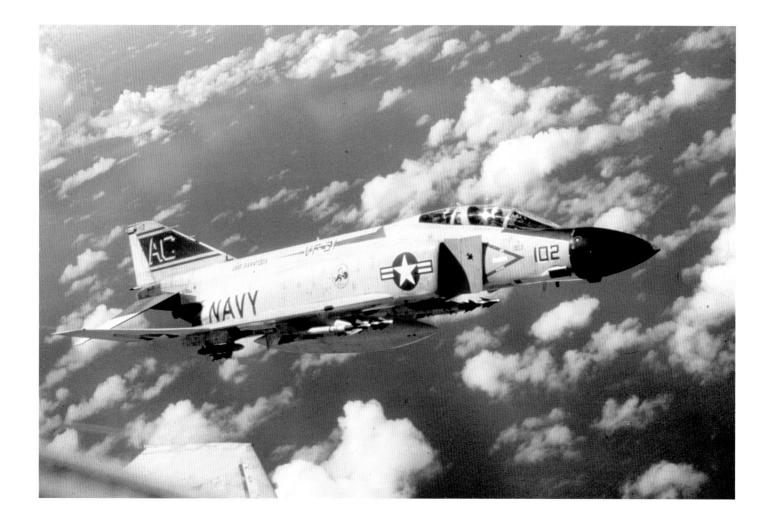

Long before his fall. U.S. Navy pilot Lt. Randy Cunningham and radar intercept officer Lt. j.g. Willie Driscoll have good reason to smile: note the eight red victory markings on their Phantom. On May 10, 1972, Cunningham and Driscoll shot down three MiGs over North Vietnam, bringing their victory total to five and making them the war's first aces.

That day didn't end easily though. On the way home, they were hit by a SAM missile and struggled to reach the relative safety of the open sea, where they ejected and were recovered. Cunningham was nominated for the Medal of Honor, and he became one of the most decorated pilots of the war, receiving among other honors the Navy Cross and two Silver Stars.

Cunningham served as an instructor at the Navy's Top Gun school, then went on to other assignments before retiring from the Navy in 1987. His renown as a CNN commentator and his heroic military background made him a prime candidate for Congress. He won a House seat in 1990 and was repeatedly reelected, but the controversial representative succumbed to the temptations of power. "Duke" Cunningham pleaded guilty in 2005 to charges of bribery, fraud, and tax evasion. The war hero who had eluded capture by the North Vietnamese was sentenced to eight years in prison.

"The End of the Plain Plane." No airline in the 1960s and '70s displayed more stylish pizzazz than Braniff International. Its new corporate owners made it their mission to remake the successful but stodgy airline into a vibrant, top-tier carrier by overhauling everything from where it flew to the food it fed its passengers (which soon included the inspired BRANwich).

To reinvent the company's image, Braniff hired a New York ad agency, which tackled the task with relish. They brought on board internationally acclaimed design talents Alexander Girard and Emilio Pucci to reimagine aircraft paint schemes, airport lounges, uniforms, logos. Out went the traditional red, white, and blue airplane colors; in came a jelly bean bag's worth of pastel hues. Pucci introduced space age–inspired stewardess uniforms that the cartoon family members of Hanna-Barbera's Jetsons would have envied. The outfits included bubble helmets to ensure that a gal's hairdo wouldn't get mussed while crossing a windy tarmac.

In 1973, to promote its South American destinations, Braniff commissioned artist Alexander Calder to create a unique work that would grace a DC-8 jetliner. The result, pictured here, was the exuberant *Flying Colors*. Calder created another work for Braniff in 1975, the Bicentennial-themed *Flying Colors of the United States,* using a Boeing 727 as his canvas.

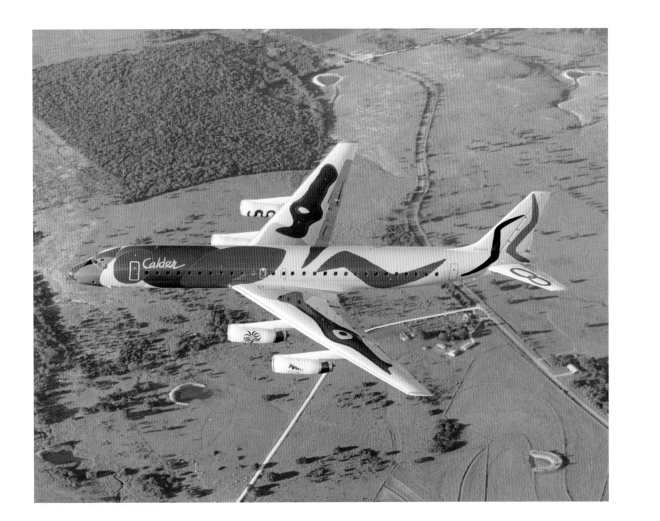

The incomparable Concorde. The cabin was small by modern standards, not much wider than a 1930s DC-3. A single narrow aisle divided the 50 pairs of leather passenger seats. The overhead bins were tiny, as were the windows; you could almost cover one with your hand. The service was impeccable; the clientele, exclusive; the view, breathtaking, as was the ticket price, which ran in the thousands—one way.

New York to London in under three and a half hours; what a way to fly! The Concorde roared upward toward its own private airspace, between 50,000 and 60,000 feet. You could look down on jumbo jets cruising five miles beneath you and traveling less than half as fast. You could actually see the curvature of the Earth. You smoothly slipped past Mach 2 with only a slight bump as the afterburners kicked in. You wouldn't know you were moving twice the speed of sound—some 1,350 miles per hour—if not for the Mach readout at the front of the cabin. The plane grew so hot from frictional heat that it expanded more than half a foot in length during flight.

Jet fuel was cheap when the Concorde was born, but it didn't stay that way for long. Stratospheric fares and route restrictions kept demand low, and the immutable laws of economics prevailed. The last of the 14 British Airways and Air France Concordes ceased flying in 2003 after 27 supersonic years.

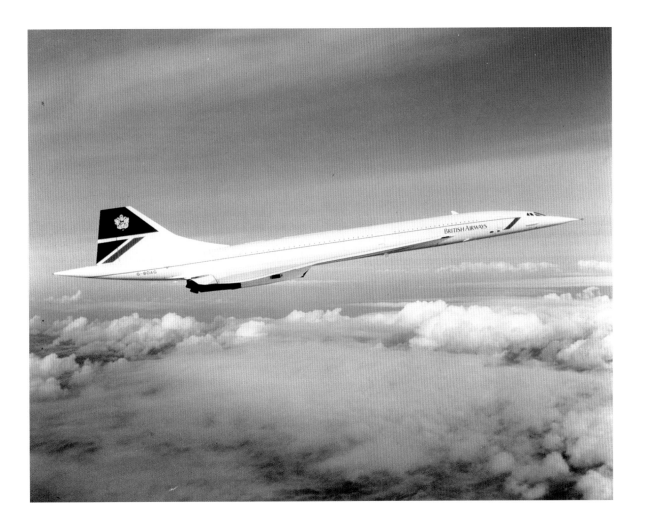

At home in space. The Skylab Orbital Workshop sails above a cloud-veiled ocean, as seen from the third Apollo command module to transport astronauts to America's first space station. A trio of three-man crews occupied Skylab from May 1973 to February 1974, spending a total of 171 days in space—more time than all previous spaceflights in history combined.

Like a terrestrial home, Skylab appears in the midst of renovation, with one solar panel absent and what looks like a gold tarp covering the crew habitat, as if to keep out the rain while the roof is being repaired. In actuality, the astronauts' orbital mobile home suffered serious damage when launched into space on an unmanned Saturn V.

A meteoroid shield ripped off during launch, taking one of Skylab's two solar panels with it and fouling the deployment of the other. The lack of the protective shield caused temperatures inside to rise to uninhabitable levels, and the solar panel problems reduced Skylab's electrical power. The first Skylab crew had to make some home repairs before the space station could be lived in. They manually freed the solar panel and set up a sunshade, then resided there in spacious comfort for almost a month.

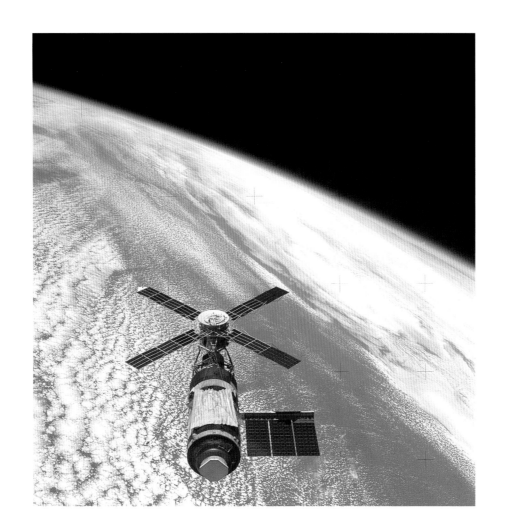

At work in space. Despite its damage, Skylab proved to be a great success. The nine astronauts who lived in the aptly named Orbital Workshop performed hundreds of technical and scientific experiments, many involving Skylab's custom-designed solar observatory. Each three-man crew spent more time in Skylab—28, 59, and 84 days—allowing scientists to study the effects of long-term spaceflight on the human body.

The unexpected repairs had their positive side: they provided much valuable experience in performing extravehicular activities, or EVAs. This photo, taken by pilot Jack Lousma during the second manned mission, shows mission scientist Owen Garriott working outside the space station. Altogether, Skylab astronauts performed ten separate EVAs totaling 42 hours.

After the last astronaut crew departed, Skylab was shut down and placed in a stable orbit. However, unexpectedly strong solar activity caused it to lose altitude sooner than expected. With no ready means to boost Skylab to a higher orbit (Space Shuttle flights were still years away), NASA decided to allow the dormant space station to fall back to Earth. On July 11, 1979, Skylab plowed into the atmosphere and incinerated, its remains scattering safely across the southeastern Indian Ocean and sparsely inhabited parts of Western Australia.

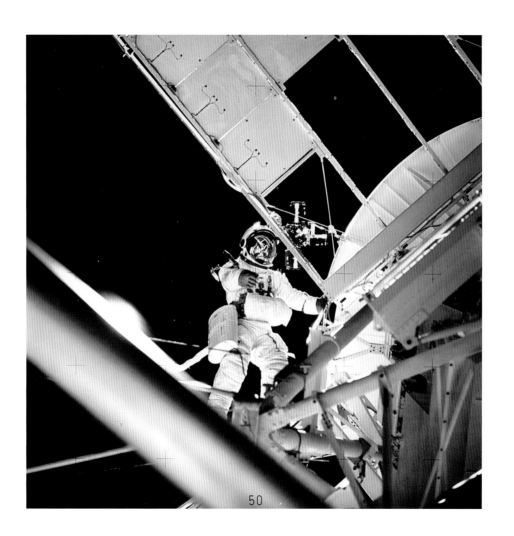

50

The Soyuz half of Apollo-Soyuz. The cosmonaut crew of the Apollo-Soyuz Test Project poses in front of the mission logo during training. Aleksei Leonov (left) was already a legend. One of the original cosmonauts, he had performed the first spacewalk in history, during which he nearly got stranded outside his spacecraft. Valeri Kubasov (right) had flown on Soyuz 6. Both had been slated to fly on Soyuz 11, but a medical issue grounded them. The crew who took their place perished when their spacecraft depressurized during reentry.

The Apollo crew that would meet Leonov and Kubasov in space included its own luminaries. Spaceflight veteran Tom Stafford had flown on two Gemini missions and Apollo 10. Deke Slayton was one of the original Mercury 7 astronauts, but because of a medical condition he had not yet flown. Crewmate Vance Brand was a spaceflight rookie too.

On July 17, 1975, the Apollo and Soyuz capsules rendezvoused in orbit and linked up via a docking module. Stafford climbed into the module and, through the open hatch of the Soyuz, shook hands with Leonov, a greeting televised to the world. The crews spent two days together before going their separate ways. Their mission of goodwill marked the first joint venture in space by the two nations—a brief thaw in the Cold War and a promise of warmer relations to come.

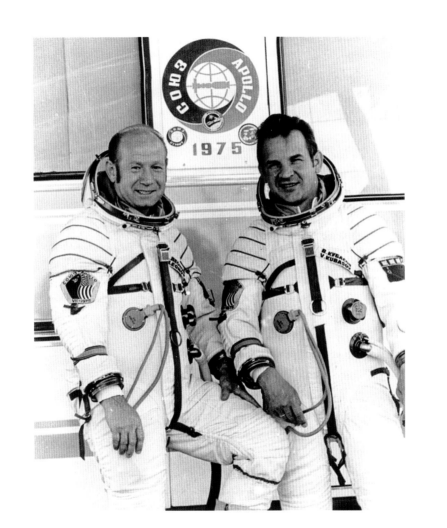

New horizons. The theories of astronomer Percival Lowell, who thought that Mars might be webbed with canals, and the fiction of Ray Bradbury, who imagined a serene civilization on a lush, temperate Mars, had been discredited long before two spacecraft touched down on the surface during the Bicentennial summer of 1976. But what the Viking 1 and Viking 2 landers revealed, if less fantastic, was still momentous: a transcendent view of another planet as a world.

Unlike the gray, austere, airless Moon, Mars appeared almost inviting, even familiar. Appearances were deceptive, of course, given the planet's frigid temperatures, violent winds, and air far too thin to breathe. The landers discovered no traces of life, past or present.

In this Viking 2 photo, a rock-strewn plain named Utopian Planitia extends toward the horizon. The colors are true—note the American flag and the color calibration charts. The presence of iron oxide gives the surface its rusty color, and dust particles suspended in the atmosphere give the sky its salmon hue.

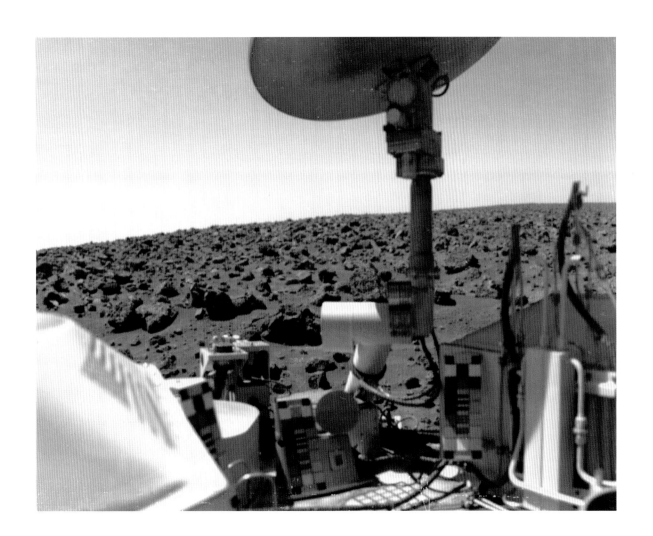

Following in Lindbergh's path. On August 17, 1978, a half-century after Charles Lindbergh flew from New York to Paris, three aeronauts became the first to cross the Atlantic by balloon. At least 17 other attempts had been made, starting as early as 1873, and seven lives lost. By the late 1970s, the race to be the first was heating up.

Two of the three, Ben Abruzzo and Maxie Anderson, had tried and failed in 1977. On July 30, 1978, two Englishmen fell short by just 103 miles and were preparing to try again. Less than two weeks later, Abruzzo, Anderson, and Larry Newman lifted off from Presque Isle, Maine, in Double Eagle II. After several smooth days, they had their most harrowing moment. Clouds caused the gas in the balloon envelope to cool, and Double Eagle II plunged from well over 20,000 feet to a mere 3,500 before recovering.

Success was officially theirs when they crossed the Irish coast. They had hoped to reach le Bourget Airfield near Paris, where Lindbergh had landed, but low ballast and fading light forced them to land their *Spirit of Albuquerque* gondola in a barley field in Normandy. They had been aloft for 137 hours and 3,100 miles. If the flight didn't end quite as planned—Newman had hoped to hang glide to a landing—they nonetheless had faced a century-old challenge and triumphed.

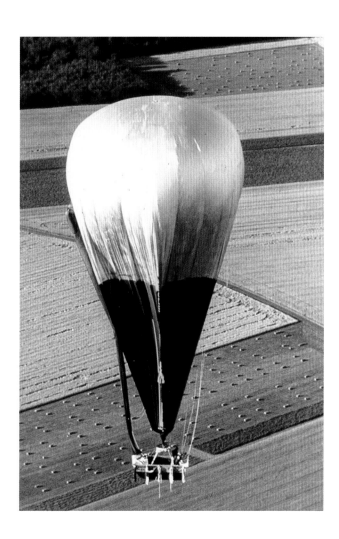

A flying fuel tank. Sixty-two years after two Douglas World Cruisers circled the globe by air for the first time, pilots Dick Rutan and Jeana Yeager repeated that feat. While it took the *Chicago* and *New Orleans* 175 days and 74 stops in 1924, it took Rutan and Yeager 9 days in 1986—without stopping or refueling.

Their unconventional aircraft, *Voyager,* was the creation of unconventional thinker Burt Rutan, famous for his innovative aeronautical designs. Rutan designed *Voyager* to wring the most distance possible out of every ounce of fuel, of which *Voyager* contained many. Fuel, in fact, accounted for nearly three-fourths of its total takeoff weight. Structurally, *Voyager* consisted almost entirely of lightweight composite materials. Its cramped cabin area was not much bigger than an old-fashioned phone booth.

The upturned winglets date this photo to before *Voyager*'s historic flight. At the start of that flight at Edwards Air Force Base, California, during a takeoff roll that exceeded 2½ miles and two minutes, *Voyager*'s fuel-laden wings drooped so low that the winglets dragged along the runway and were nearly ground off. Once airborne, the pilots managed to dislodge them and continue on.

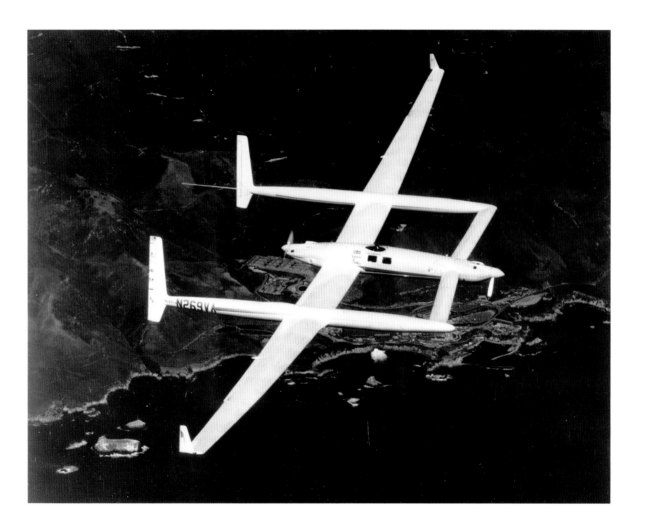

FAST times at DFW. The controllers pictured here at the Dallas/Fort Worth TRA-CON (Terminal Radar Approach Control Facility) in 1996 were testing a new automation tool called FAST (Final Approach Spacing Tool). Developed by NASA's Ames Research Center, FAST was designed to help controllers manage arriving traffic by automatically providing aircraft landing sequences and runway assignments.

On any day, 5,000 to 7,000 commercial aircraft (along with private and military aircraft) may be in the air at once over the lower 48 states. More than 16,000 air traffic controllers monitor and direct the movements of those aircraft. Their primary responsibility is to keep the aircraft safely separated. With the lives of some one to two million air travelers a day at stake, theirs is a crucial and complex task.

Controllers in airport towers manage aircraft landing and taking off and on the ground. Controllers at TRACONs direct aircraft within about 5 to 50 miles of an airport. Others at control centers across the country monitor aircraft en route to their destinations. The system's command center in Herndon, Virginia, oversees the entire national airspace and manages air traffic flow during major weather events and other emergencies, such as the clearing of the skies on the morning of September 11, 2001.

Just before the dawn. Space Shuttle *Columbia* awaits the start of its historic first mission, STS-1, on April 12, 1981. The first spacecraft designed for repeated use, the Space Shuttle opened a new era in spaceflight. Although Shuttle flights never became as routine as originally planned, the Space Transportation System (STS) has enjoyed well over a hundred successes and suffered two heartbreaking failures: *Challenger* in 1986, *Columbia* in 2003.

Notable in this time exposure night shot is the white external fuel tank between the twin booster rockets. External tanks were left unpainted after the first two Shuttle missions, saving about 600 pounds of weight and exposing the tan color of their spray-on foam insulation.

Powered into orbit by solid-propellant booster rockets and liquid-propellant rocket engines, capable of transporting and placing large payloads in orbit, designed to survive a scorching reentry and then glide to a runway landing, the Space Shuttle is an exceedingly complex and robust system. Yet it can also be surprisingly vulnerable. In 1995 northern flicker woodpeckers riddled the foam insulation on *Discovery*'s fuel tank with some 200 holes, causing NASA to delay the launch while the damage was repaired. In 2003 a piece of foam insulation that broke loose during *Columbia*'s launch caused damage to the wing that ultimately led to the Shuttle's destruction during reentry.

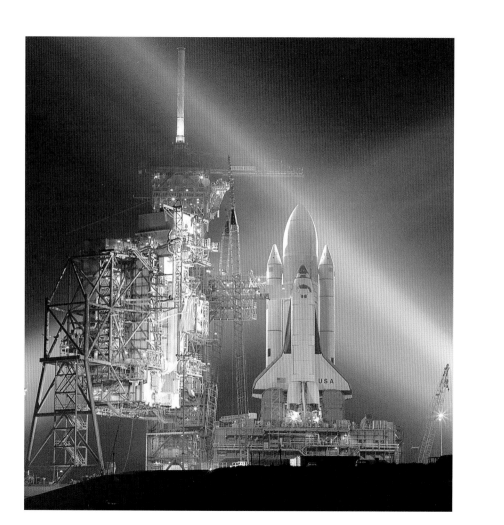

***Endeavour*'s first flight.** A new Space Shuttle orbiter began its initial journey to Kennedy Space Center after its rollout in Palmdale, California, on April 25, 1991. The fifth space-worthy Shuttle, *Endeavour* was built to replace the ill-fated *Challenger*. It arrived at Kennedy on May 7 and made its first flight into orbit one year later.

Endeavour's cross-country journey also marked the first use of NASA's newest Shuttle Carrier Aircraft, the second of two heavily modified Boeing 747 airliners (designated NASA 905 and NASA 911) employed to transport orbiters to the Kennedy Center launch site. NASA tries to minimize their use, as the aircraft are extremely expensive to fly. An orbiter's added weight and drag reduces the 747's range to only about 1,200 miles and its fuel consumption to around 125 *feet* per gallon. The aircraft burns two gallons just to travel its own length.

The James Bond film *Moonraker* notwithstanding, an orbiter can't take off in midair, even if its engines weren't covered by an aerodynamic fairing and its fuel tank sitting in Florida. Still, there is a touch of humor evident in the Shuttle transport operation. Boldly printed on one of NASA 905's three mounting struts is this cautionary instruction: "ATTACH ORBITER HERE. **NOTE:** BLACK SIDE DOWN."

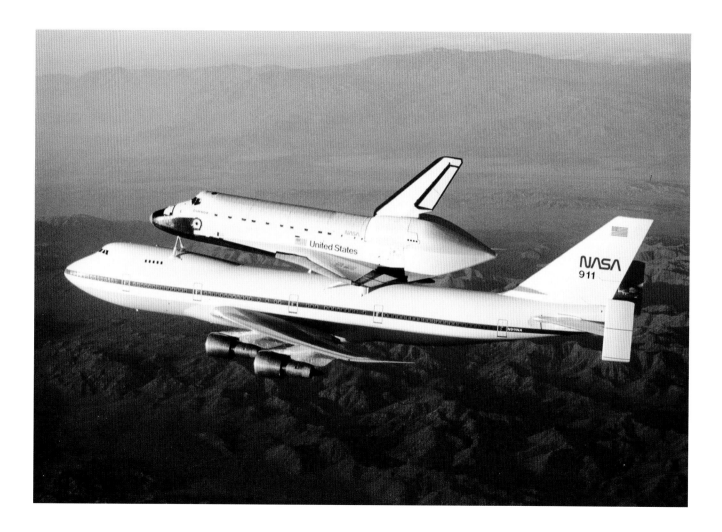

The new face of spaceflight. During the first two decades of human spaceflight, spacecraft were literally and almost exclusively *man*ned, mostly by white male military test pilots. In 1963 Russian cosmonaut Valentina Tereshkova spent three days aboard Vostok 6 to become the first woman in space. But her selection was more propaganda ploy than anything else—one more Soviet first in the space race. The Soviet Union did not send another woman into orbit until 1982.

The Space Shuttle era brought greater opportunities for spaceflight and broader diversity to the astronaut corps. Sally Ride, shown here on *Challenger*'s flight deck, became the first American woman in space in 1983, almost exactly 20 years after Tereshkova's flight. A mission specialist with a Ph.D. in physics and an integral role to play, Ride was no novelty; along with the five other women in her astronaut class, she was a harbinger of change.

Since then, more than three dozen American women have flown in space, and the racial and ethnic mix of astronauts has edged closer to that of the nation. Ride flew again in 1984 and served on both commissions that investigated the *Challenger* and *Columbia* accidents. Since leaving the astronaut corps, she has devoted herself to encouraging girls and young women to pursue careers in science, math, and technology—a latter-day Amelia Earhart on the new frontier of space.

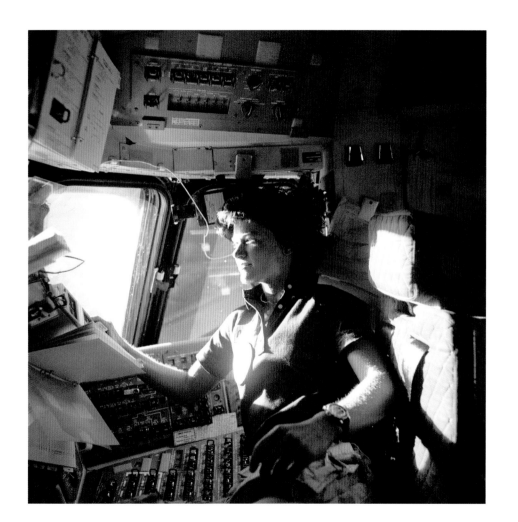

Free flying. Bruce McCandless takes the first untethered walk in space, using a Manned Maneuvering Unit (MMU) during a Space Shuttle mission in 1984. The self-contained backpack propulsion device allowed him to move about freely in space, effectively making him a one-man spacecraft. McCandless flew more than 300 feet from the safe haven of *Challenger*. His assessment of the MMU, which he helped develop: "We sure got a nice flying machine here!"

To use the device, a suited-up astronaut would exit a Shuttle's crew compartment through an airlock into the cargo bay, where two MMUs were stored. He would snap the MMU onto his back and use its hand controls to fire the unit's 24 nitrogen gas thrusters. He could activate an autopilot system to hold himself in place and free his hands for other work. The MMU had enough propellant for hours of use—a far cry from the "zip" guns used by tethered Gemini spacewalkers.

MMUs were used on two more Shuttle missions in 1984. During one they helped astronauts retrieve two communication satellites stranded in incorrect orbits. Despite the MMU's success, the changing focus of Shuttle missions eliminated most of its uses. To construct the International Space Station, NASA chose to resume tethered spacewalks.

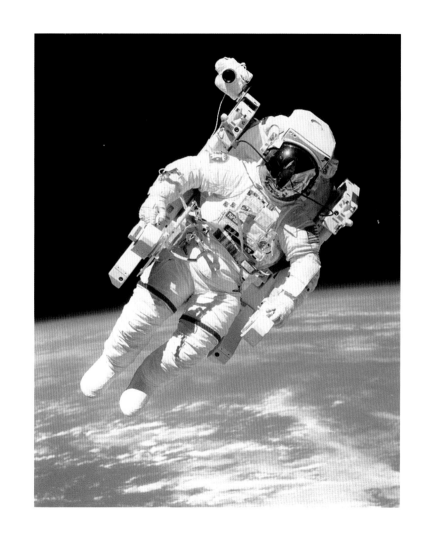

Service call in space. Space Shuttle *Discovery*'s robotic arm lifts the Hubble Space Telescope away from the spacecraft at the end of Hubble's second servicing mission, in 1997. Placed in space by *Discovery* in 1990, Hubble was designed to be retrieved in orbit every few years for servicing and upgrading, which has helped it remain one of the world's most powerful and versatile astronomical research tools.

During the first servicing mission, *Endeavour* astronauts installed new solar arrays, a new camera, and an optical device that corrected Hubble's notorious optical flaw—its main mirror was misshapen by less than 1/50th the thickness of a human hair. Its vision adjusted, Hubble began returning pictures that continue to boggle the imagination, from the sharpest telescopic views ever taken of our neighboring worlds to deep-sky images that captured the youngest, faintest, and farthest galaxies ever seen.

On this mission, *Discovery* astronauts replaced two old observing instruments with two new ones: the STIS, a powerful imaging spectrograph, and NICMOS, a spectrometer that extended Hubble's light sensitivity from visible and ultraviolet into near infrared. They also performed various other maintenance and repair chores, doing everything but checking the oil and washing the windshield.

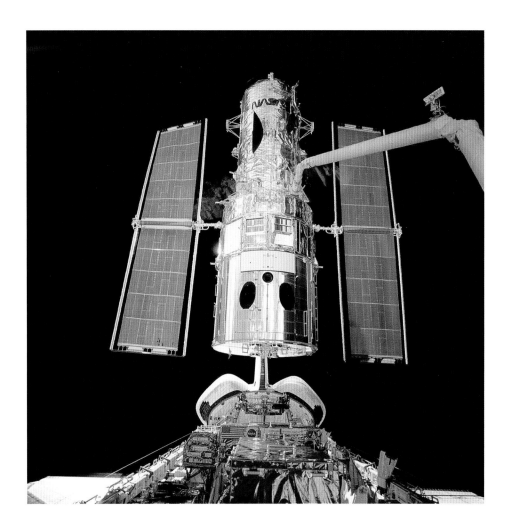

Mission to Mir. Having been bested in the race to the Moon, the Soviet Union focused on establishing a human presence in Earth orbit. Starting in 1971, the Soviets launched a series of single-module Salyut space stations, which they occupied for increasingly longer durations. In 1986 they began constructing in space the more elaborate, multiple-module Mir.

It took ten years to complete the Mir space station, during which time the Soviet Union collapsed, opening the way for more cooperation in space between the United States and Russia. *Atlantis* in 1995 became the first Space Shuttle to visit Mir, delivering tools, equipment, supplies, and a replacement cosmonaut crew. The joined Mir-Shuttle produced the largest spacecraft ever in orbit up to that time. Just before *Atlantis* departed, the two cosmonauts remaining behind undocked their Soyuz spacecraft and captured this view. The cylindrical Spacelab research module rests in the Shuttle's cargo bay.

Cosmonauts and guest astronauts from many nations occupied Mir almost continuously for 13 years. But the space station was beset with problems and mishaps, and with development of the new International Space Station under way, the aging Mir was abandoned. Directed to reenter the atmosphere in 2001, it disintegrated over the South Pacific.

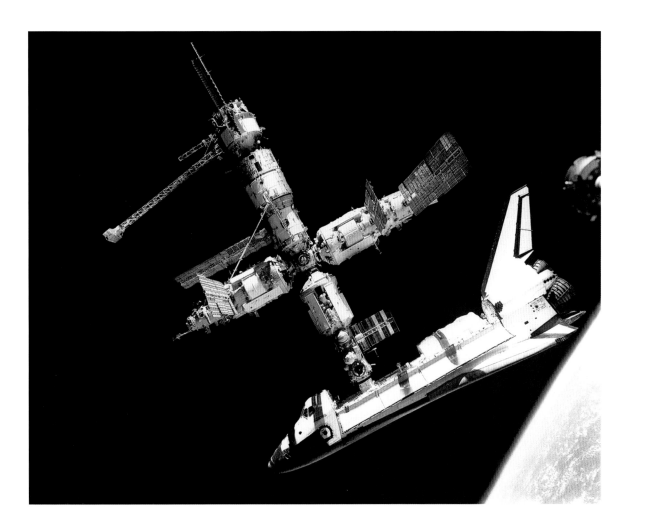

Go for launch. With jets roaring at full throttle against the blast shield behind his F-14, the pilot signals his readiness with a salute and braces himself. The catapult officer returns the salute, checks the ship's bow a final time, then drops to his knee, touches the deck, and points into the wind. The firing of the steam catapult that will sling the Tomcat off the USS *Kitty Hawk* is an adrenaline-fueled heartbeat away.

Choreographing the launch and landing of dozens of aircraft laden with fuel and ordnance on a crowded, sea-tossed airstrip requires the utmost precision and care. Potential catastrophe is ever present—an explosion or fire, aborted launch or crash, a crew member sucked into a jet's intake or blown overboard by its exhaust. Deck crew wear color-coded jerseys and helmets to identify their role in the controlled chaos, and they rely on hand signals to communicate amid the deafening noise.

Kitty Hawk headed a new class of supercarriers designed to project U.S. air power around the globe. By the time this 1979 photo was taken, even larger, nuclear-powered carriers had taken to the seas, and the new F/A-18 Hornet, successor to the F-14 Tomcat of *Top Gun* movie fame, was being tested. But *Kitty Hawk* would continue to serve for three more decades, and the carrier flight deck would remain one of the world's most perilous places to work.

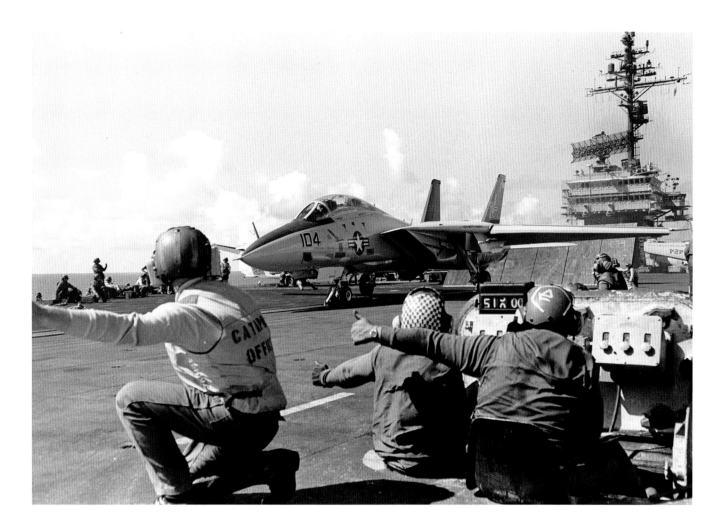

Fueling up. Slowed to mere subsonic speed at a conventional altitude, a Lockheed SR-71 Blackbird refuels from a Boeing KC-135 tanker. Once topped off, the reconnaissance plane will disconnect, fire its afterburners, and return to its preferred cruising altitude and speed—as high as 85,000 feet, as fast as Mach 3.3. No other jet aircraft has ever gone higher or faster.

The Blackbird was the ultimate product in a series of spy planes designed during the chilliest days of the Cold War by Lockheed's crack "Skunk Works," which specialized in advanced and often top-secret aircraft. The legendary Clarence L. "Kelly" Johnson headed the unit and the SR-71 project. Famous for his innovative designs, Johnson had played key roles in the creation of such pioneering aircraft as the twin-engine P-38 Lightning, the Constellation airliner, the F-80 (America's first jet fighter), the Mach 2–capable F-104 Starfighter, and the U-2 spy plane.

The SR-71 was especially challenging. It required custom-designed engines, titanium alloy skin that could withstand frictional heat of up to 800°F, and a radar-eluding shape and finish. "It was no easy task," Johnson once explained. "Everything about the SR-71 had to be invented from scratch…. I offered a $50 reward to anyone who could come up with an easy answer. I still have the $50."

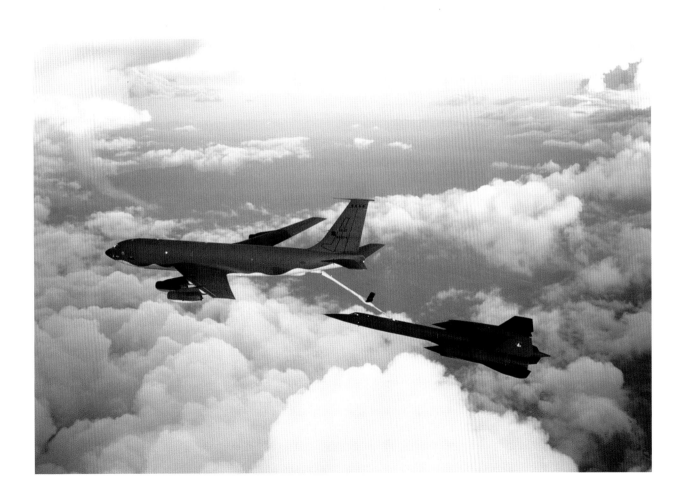

The tip of the spear. Crew chief Staff Sgt. David Owings directs pilot Maj. Joe Bowley in his Lockheed F-117 Nighthawk following Operation Desert Storm in 1991. The sharply faceted F-117 was the world's first operational stealth aircraft. More sophisticated computer modeling would allow aircraft designers to give the newer B-2 Spirit a smoother, even stealthier, and far more aerodynamic shape.

Despite its designation, the F-117 "stealth fighter" was really a precision-strike night bomber. Top secret for many years, Nighthawks finally saw combat over Panama in 1989, but their first real test against formidable defenses occurred when they spearheaded the air assault that launched Desert Storm.

The devastating five-week air campaign against Iraq and its forces in Kuwait, and the brief 100-hour ground war that followed, finally seemed to validate the long-held beliefs of air power advocates. Since the 1920s, many had argued that air power would grow so decisive that it would greatly shorten or even prevent future wars. A dozen years after Desert Storm, the full might of U.S. air power was again unleashed against Iraq with even greater effectiveness. But while military victory on the ground again quickly followed, peace proved elusive.

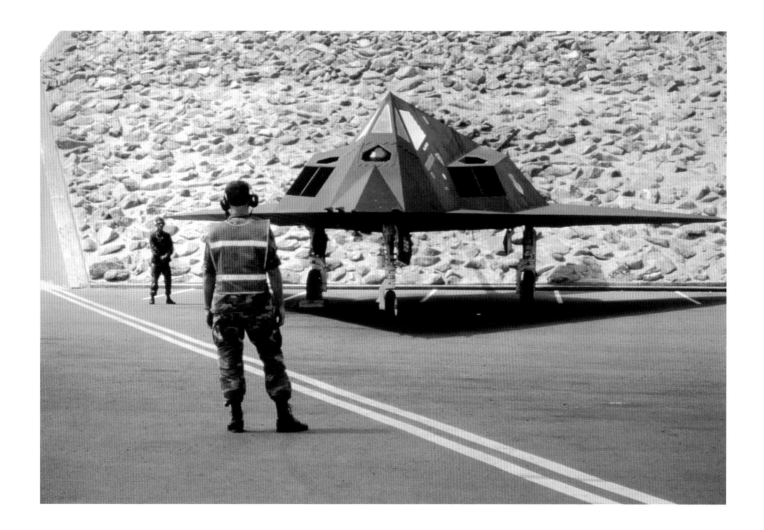

Spirit in the sky. It vaguely resembles a cross between a bat ray and a boomerang, but with smooth contours trailing off to a jagged edge. It can fly nearly 7,000 miles without refueling and can strike anywhere in the world within 24 hours. A one-aircraft aerial armada with a two-person crew, it can disperse the 40,000 pounds of weapons it carries internally against dozens of separate targets. The modern face of strategic bombing, it shows almost no face at all.

The Northrop-Grumman B-2 Spirit reflects the ultimate in stealth technology. Composite materials, a radar-absorbing coating, and its unique flying wing design make the aircraft almost invisible to radar and reduce its visible, acoustic, electromagnetic, and infrared "signatures" as well. Much of its stealth technology remains classified.

First unveiled in 1988 and operational since 1993, B-2s have seen service over the Balkans, Afghanistan, and Iraq. With the Soviet Union's collapse, the number built was reduced from a planned 135 to only 21. Until 2003 all B-2s were based at Whiteman Air Force Base in Missouri, and missions typically lasted well over 30 hours and required multiple aerial refuelings. Stealth bombers have since been deployed to the British island of Diego Garcia in the Indian Ocean and Guam in the Pacific.

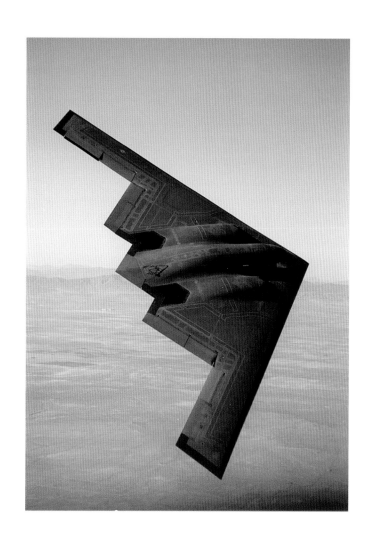

At the controls. These unidentified crew members pilot a Boeing B-52H Strato-fortress, the ultimate version of the venerable Cold War bomber. Their cockpit is a marvel of sophistication compared to those in which early pilots flew. But in 1982, the year this photo was taken, a revolutionary flight control system would debut that would make this cockpit seem as quaint as the one in the *Spirit of St. Louis*.

In the early 1970s, NASA developed digital "fly-by-wire" technology, which uses electronic signals and computers to control an aircraft rather than mechan-ical and hydraulic systems. In 1982 the "glass cockpit" was introduced; it sub-stituted computer displays for many of the cockpit's vast arrays of gauges and switches. New Boeing and Airbus airliners sported early versions of the system. Then in 1988 the Airbus A320 became the first airliner with an entirely digital fly-by-wire system and a fully "glass" cockpit.

Digital flight control has not only proven safer and more efficient, but the less cluttered cockpit environment and computerized displays have also made the flight crew's job easier. Digital systems have become standard on new com-mercial and military aircraft, and NASA has refitted its Space Shuttles with glass cockpits. The technology has now trickled down even to general aviation aircraft.

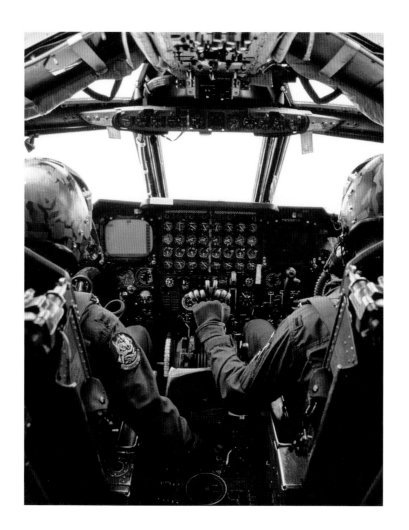

Unstable at any speed. The military made the first use of NASA's digital fly-by-wire technology. The F-16 Fighting Falcon, a lightweight, multi-role fighter developed by General Dynamics and introduced by the Air Force in 1978, became the first aircraft to incorporate the system. The airplane flies the pilot as much as the pilot flies the airplane; in fact, without computer assistance, the pilot alone simply cannot control it.

Fly-by-wire allowed engineers to design the F-16 to be aerodynamically unstable (another first), which enhanced its maneuverability, making the fighter extremely agile in combat. To maintain flight, its computer control system performs thousands of calculations and attitude corrections each second. If the fly-by-wire system ever failed, the aircraft would instantly tumble out of control and disintegrate.

Sharper, faster turns means higher g-forces, so the F-16 was built to sustain 9 g's (yet another first) rather than 7. The seat is reclined to help the pilot endure the higher accelerations. A bubble cockpit provides an unobstructed view, and a Head-Up Display places aircraft performance and weapons information in the pilot's field of vision. The Mach 2 fighter has proven so successful that many of its revolutionary features are now standard on new generations of fighters.

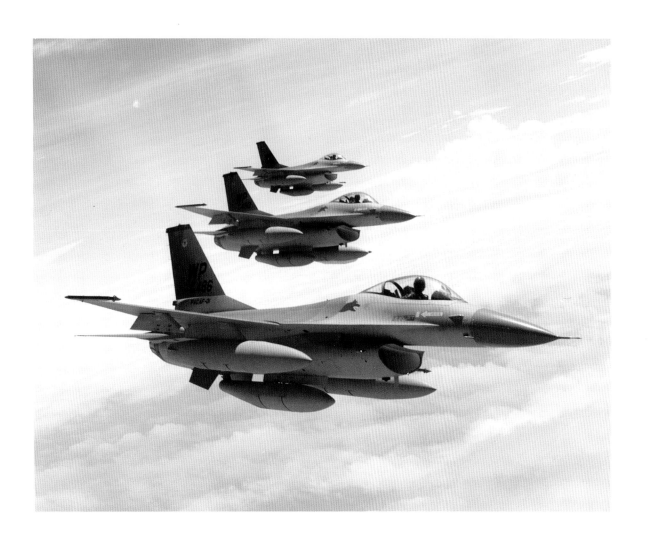

Around the world in 20 days. What was billed as "the last great aviation challenge of the century" involved the oldest method of human flight. The world had been circumnavigated by airplane (1924), by helicopter (1982), and even non-stop by airplane without refueling (1986). But no one had done it in a balloon, although many had tried.

During the 1980s and '90s, 16 unsuccessful attempts were launched, including two by Bertrand Piccard, a Swiss aviator. Piccard seemed born to the challenge. His grandfather had developed the pressurized balloon gondola and flown in the first balloon to reach the stratosphere.

Piccard's third attempt, with Brian Jones in the Breitling Orbiter 3, proved to be the charm. Shortly before this photo was taken on March 1, 1999, Piccard and Jones lifted off from Château d'Oex, Switzerland, beneath their hot-air and helium balloon and drifted east. Some 28,000 miles and 20 days later, they landed in the Egyptian desert after circling the globe. Within their pressurized gondola, about as roomy as a small RV, they had overcome confinement, frigid cabin temperatures, and other physical and mental hardships to achieve the final aviation first of the 20th century.

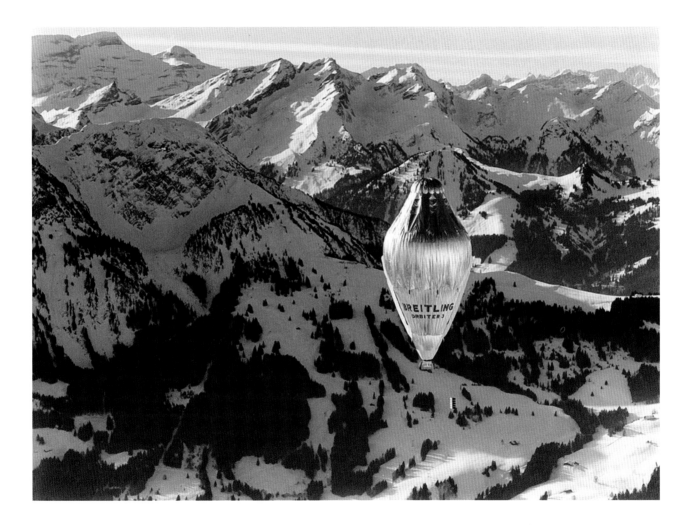

The "Un-NASA." An Ariane launch vehicle blasts off from the Centre Spatial Guyanais in French Guiana, on the Atlantic coast of South America. These names, unfamiliar to most Americans, are associated with the European Space Agency. Established in 1975, ESA coordinates the resources and capabilities of its member nations (16 European countries and Canada) to provide access to space and undertake projects beyond the means of any single member.

ESA also oversees development of the Ariane rocket, its principal launch vehicle, now in its fifth generation. The agency located its spaceport in French Guiana to take advantage of the extra "boost" a rocket gets from the Earth's rotation when launched close to the equator. The company Arianespace, which produces and launches the rockets, has become the world's foremost commercial launch service.

Small and efficiently structured, compared to the far larger and more bureaucratic NASA, ESA has become a major player in space. While it works cooperatively with NASA on many projects, it has its own extensive slate of research projects and space missions. It also has ambitious plans for the future, including robotic and human missions to Mars.

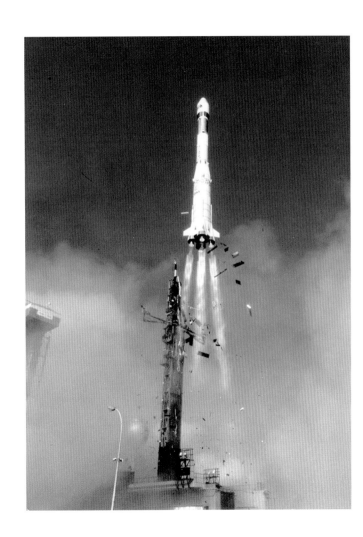

A 2001 space odyssey. After undocking from the International Space Station on August 20, 2001, Space Shuttle *Discovery* flew around the complex to photograph its progress and to provide the station's departing three-person crew a last look at their home in space for five and a half months. Two of the ISS's larger modules dominate this view. A Russian Soyuz spacecraft is docked at the near end.

A work in progress, the International Space Station is a joint effort by the American, Russian, European, Japanese, and Canadian space agencies, which combined their individual plans for orbital space facilities into one. The first two of ten main pressurized modules planned for the ISS were launched in 1998. The first crew arrived in 2000, and the station has been occupied continually ever since. It may ultimately support six people at a time.

The ISS is not quite what Dr. Wernher von Braun envisioned in the 1950s—a huge rotating wheel providing artificial gravity through centrifugal force—and it falls far short of the space facilities Arthur C. Clarke imagined we would be visiting by 2001. But despite massive budget overruns, construction delays, structural changes, and controversy over its utility and benefits, the ISS has evolved, truss by module, into the largest habitat in space humans have ever built.

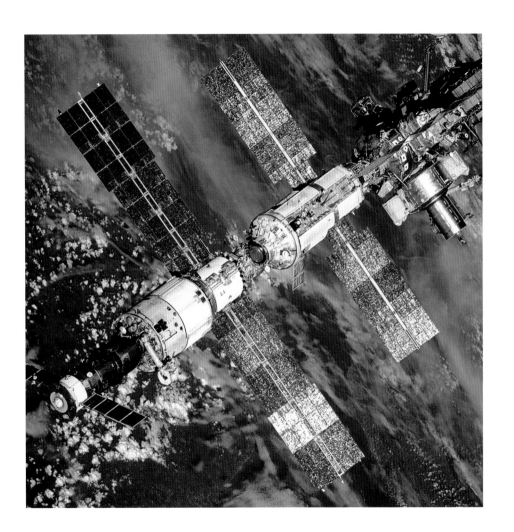

"Like a hummingbird." A pair of U.S. Army OH-58D Kiowa Warriors leave the Mosul headquarters of the 3-502nd Infantry Regiment, 101st Airborne Division (Air Assault), during Operation Iraqi Freedom in 2003. The armed reconnaissance helicopters feature the distinctive Mast-Mounted Sight (the device above the rotor blades), which houses a television system, thermal imaging system, and laser rangefinder/designator for day and night combat operations.

"The aeroplane won't amount to a damn thing until they get a machine that will act like a hummingbird," said one Thomas Edison in 1905 with the age of flight just on the rise. The brilliant inventor was unaccountably shortsighted in regard to the airplane, but those mechanical hummingbirds Edison wished for have proven their worth in ways even he could not have imagined.

Besides being militarily indispensable, helicopters fill a multitude of civil roles—law enforcement, border patrol, drug interdiction, firefighting, search and rescue, medevac, crop spraying, livestock management, construction work, traffic monitoring, movie production, sightseeing, and more—even if dreamy visions of personal helicopters flying up and away from backyard helipads have not (yet) taken wing.

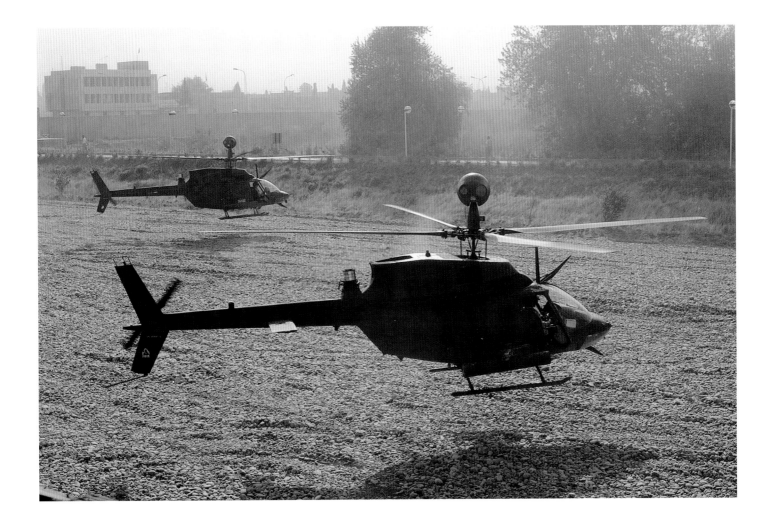

The going. Against a backdrop of bigger airplanes bound for farther places, a United Express turboprop awaits its next group of travelers at Washington Dulles International Airport in Northern Virginia. The date is August 13, 1994, but it could just as well be today.

If you are one of those taking this plane, you will enjoy the almost nostalgic thrill of walking outside to board. You will fly at an altitude that doesn't flatten the hills, low enough to discern individual cars and trees. You may land at an airport with gates numbered 1 to 3; where check-in and security lines are short, you retrieve your luggage from a broad metal trough, and your car awaits in a parking lot right outside the terminal doors.

Before hijackings to Cuba, before Pan Am 103, before September 11, 2001. . . . You saw loved ones off at the gate and greeted them there with a hug when they returned. You immersed yourself in the airport's exhilarating atmosphere, charged with the anticipation of travel. You watched the planes take off and land from the observation deck with dreaminess in your eyes. You looked forward not just to the getting there, but to the going. . . .

And, despite all that's changed, you still love to fly.

Legacy of flight. Boeing's newest and oldest jetliners parade across the sky. The 777-300ER, rolled out in 2002, is the latest in Boeing's state-of-the-art 777 line. Above it, the newly restored 367-80, or "Dash 80," was the prototype for the 707, the airliner that introduced Americans to jet travel.

The Dash 80 touched down for its final time in August 2003 at Washington Dulles International Airport, where its crew turned the airplane over to the National Air and Space Museum for display in its new companion facility there. The Museum's Steven F. Udvar-Hazy Center opened December 15, 2003, just in time to celebrate the 100th anniversary of the Wright brothers' historic flights. Along with the Dash 80, awestruck visitors wander among a vast and ever-growing collection of aircraft and spacecraft that include Samuel P. Langley's Aerodrome No. 5, Roscoe Turner's *Meteor,* Wiley Post's *Winnie Mae,* the B-29 *Enola Gay,* an SR-71 Blackbird, an Air France Concorde, and the Space Shuttle *Enterprise*, to name but a choice few.

The National Air and Space Museum and its Udvar-Hazy Center present and preserve the nation's aviation and space heritage for those who want to remember, for those who want to learn, and for those dreamers, doers, and darers who will shape the next century of flight.

Home from the sky. A ground crewman crosses a pair of lighted aircraft marshalling wands above his head, an internationally recognized signal for "Stop." It often signifies that a flight has reached its end.

The "Big Blue Marble." The crew of Apollo 17 took this photograph on December 7, 1972, while traveling from the Earth to the Moon. An iconic space age image, this was the first photograph ever to capture a "full Earth."

IMAGE CREDITS

Abbreviations used
NASA = National Aeronautics and Space Administration
NASM = National Air and Space Museum Archives Division
SI = Smithsonian Institution
USAF = United States Air Force

ii photo by Hans Groenhoff, NASM HGC-1599-B
vi SI 2005-30950
3 NASM 9A00238, courtesy Smithsonian Institution Libraries
5 Original artifact donated by Dr. Robert Drapkin; artifact
 photo by Mark Avino, NASM, SI 2001-5358
7 SI 2004-25981
9 SI 96-16166
11 SI 2003-29078
13 NASM A-12600
15 Library of Congress, L'Aérophile Collection, via SI 2001-
 11566
17 SI 85-10844
19 photo by Carl H. Claudy, SI 85-10846
21 photo by Harry M. Benner, NASM 9A01255
23 SI 97-17179

25 SI 2008-3762
27 SI 2004-46233
29 SI 80-4128
31 NASM 00167283
33 NASM 7A34641
35 NASM 00145633
37 NASM 9A00225
39 SI 85-12301
41 NASM 9A00058
43 NASM A-3853
45 SI 87-6058
47 SI 89-1182
49 SI 83-390
51 SI 2003-12303
53 photo by Nathaniel L. Dewell, SI 75-7026
55 photo by Nathaniel L. Dewell, NASM 00130327
57 photo by Nathaniel L. Dewell, SI 89-7061
59 photo by Harry A. (Jimmy) Erickson, NASM A-4819-A
61 NASM 00160386
63 NASM A-4201-B
65 NASM A-672

67	SI 97-15152
69	NASM A-5194-C
71	photo by J.C. Allen, copyright 1936 Purdue University; photo provided courtesy of Purdue University Libraries' Karnes Archives and Special Collections (Purdue University Libraries-SPEC image ref. no. b12f9i9)
73	photo by Hans Groenhoff, NASM HGD-010-16
75	NASM 00065431
77	NASM 00138566
79	SI 88-6826
81	SI 98-15068
83	SI 80-17077
85	SI 2005-3686
87	NASM 00130926
89	SI 77-11793
91	SI 92-706
93	SI 2003-11742
95	SI 84-8941
97	SI 84-8936, courtesy Imperial War Museum, London, England; photo no. HU 2408
99	NASM A-45882-A
101	NASM 9A00201
103	USAF-52830AC via NASM
105	NASM A-4507-A
107	Gun camera photo by Lt. Wille L. Whitman, US Army Air Forces, SI 97-17475
109	SI 97-17480
111	NASM A-45879-F
113	NASM A-49813
115	SI 91-1471
117	SI 74-2974
119	SI 99-42462
121	NASM A-5367
123	SI 90-13117
125	SI 2000-4554
127	NASM 7A27874
129	SI 92-15613, courtesy of Bell Helicopter Textron
131	SI 86-12548
133	SI 84-3724
135	photo by Hans Groenhoff, SI 2001-1902
137	SI 91-19610
139	SI 95-3375
141	NASM 00035315
143	NASM 00131836, courtesy Federal Express
145	SI 95-8289
147	SI 90-13794
149	Rudy Arnold Photo Collection, SI 2001-5328
151	Lockheed Martin Corporation, via NASM 7B32292
153	SI 80-5653
155	SI 99-15491
157	SI 2003-36154
159	photo by Richard Rash, SI 2001-1889
161	SI 2003-30928
163	copyright Boeing, photo no. P13882

165 NASA via SI 89-5899

167 NASA via NASM 9A00303

169 SI 92-16262

171 SI 84-3712, courtesy Eugene McDermott Library, Special
 Collections University of Texas

173 NASM 00002785

175 SI 84-14155

177 NASA (61-MR3-109) via NASM

179 NASA via SI 88-6821

181 NASA via SI 99-40595

183 photo by James McDivitt, NASA Johnson Space Center (S65-
 30433) via NASM

185 photo by Apollo 8 astronauts, NASA (AS8-14-2383), via NASM
 (NASA-68-HC-870)

187 photo by Neil Armstrong, NASA (AS11-40-5903) via NASM

189 NASA Johnson Space Center (S69-21365) via SI 2004-29402

191 NASA via SI 2003-4854

193 NASA via NASM 7B31185

195 NASM 7A07341

197 NASM 00130440

199 SI 2007-1639

201 photo by Lt. Col. S. F. Watson, US Army, SI 2001-1888

203 SI 2006-20937

205 SI 85-12340

207 NASM 9A00276, courtesy Eugene McDermott Library, Special
 Collections University of Texas

209 NASM 9A00360

211 NASA Johnson Space Center (SL4-143-4706) via NASM 9A01511

213 NASA Johnson Space Center (SL3-115-1837) via NASM (NASA-
 73-HC-750)

215 NASM 00166606

217 NASA via NASM 9A01510

219 NASM 7A43915

221 SI 2001-10543

223 SI 2001-7671

225 NASA Ames (AC96-0058-1) via NASM 9A00008

227 NASA Kennedy Space Center (81PC-0136) via NASM 9A01512

229 NASA Dryden Flight Research Facility (EC 91 221-1) via NASM
 9A00331

231 NASA Johnson Space Center (S83-35783) via NASM

233 NASA via NASM 7B04457

235 National Aeronautics and Space Administration (NASA),
 Johnson Space Center (JSC) photo No. STS082-709-097, GRIN
 DataBase No. GPN-2000-001066

237 NASA Johnson Space Center (STS071-S-072) via NASM
 9A01515

239 US Navy via NASM 9A00412

241 NASM 9A00308

243 photo by Sgt. Kimberly Yearyean (USAF) via NASM 9A00617

245 USAF via NASM 9A00642

247 photo by Tech. Sgt. Alex R. Taningco, USAF, via NASM
 9A00291

249 NASM 9A00378

251 SI 2006-20925, copyright Breitling SA

253 European Space Agency (ESA) via SI 92-3996

255 NASA Johnson Space Center (STS105-707-019) via NASM 9A01516

257 US Army photo by Pvt. Daniel D Meacham, US Army, via NASM 9A01517

259 photo by Melissa A. N. Keiser, NASM 9A01518

261 copyright Clay Lacy Aviation, photo no. CLAY 9778.1.1

263 NASM 9A00606

265 photo by Apollo 17 crew, NASA Johnson Space Center (AS17-148-22727) via NASM

ACKNOWLEDGMENTS

We'd like to thank Linda Hicks of the National Air and Space Museum's Special Events Office for her idea of creating a photo presentation on the history of flight for the dedication ceremony of the Museum's Steven F. Udvar-Hazy Center. Special thanks also go to Patricia Graboske of the Museum's Publications Office, who suggested creating a book based on that presentation and ultimately found it a home; to Carole Kitchel Bellew and Ib Bellew of Bunker Hill Publishing for adopting it, raising it, and sending it off into the world; to Susannah Noel for a superb copyediting job; and to Peter Holm for his elegant design.

Many thanks as well for all our other supporters at the Smithsonian National Air and Space Museum: Von Hardesty for his thoughtful introduction; and Dorothy Cochrane, Martin Collins, Roger Connor, Tom Crouch, Dik Daso, Von Hardesty, Dan Hagedorn, Peter Jakab, Don Lopez, Valerie Neal, Mike Neufeld, Bob van der Linden, and Frank Winter for reviewing portions of the text. And we thank photographer Carolyn Russo for taking such wonderful portraits of us and making us look so good on our book jacket.

David would also like to offer his gratitude to Beatrice Mowry and to Barbara Brennan of the Museum's Exhibits Design Division: Thank you for your friendship, encouragement, and abiding support, and for enabling me to take on this and many other projects well beyond the normal call of duty.

Melissa would like to thank Allan Janus, Brian Nicklas, Patricia Williams, Kate Igoe, Mark Taylor, Kristine Kaske-Martin, Jessamyn Lloyd, and all of her colleagues in the Museum's Archives Division, past and present, whose dedication and professionalism keep the past alive and available to everyone. Special thanks go to Larry Wilson for teaching Melissa half of everything she knows about aviation, to Barbara Weitbrecht for her superior programming skills, and to Supervisory Archivist Marilyn Graskowiak for her support and encouragement.

ABOUT THE AUTHORS

David Romanowski is the writer-editor in the Exhibits Design Division at the National Air and Space Museum. He has also written the *Official Guide to the Smithsonian National Air and Space Museum* and contributed to several other books and countless exhibitions since joining the museum in 1987. He lives in Bethesda, Maryland.

Melissa A. N. Keiser joined the National Air and Space Museum Archives Division in 1985; today as Photo Archivist she cares for over 2 million images—one of the Smithsonian's largest collections of photography. She has used her image research talents in support of numerous museum publications and projects, and recently served as photo editor for the book *The Best of the National Air and Space Museum*. She lives in Alexandria, Virginia.

INDEX

aces, 38, 42, 104, 204
aerial reconnaissance, 36
aerial refueling, 240
aerobatic aircraft, 144
Aeromarine Airways, 46
agricultural aircraft, 146
air mail, 52–56, 92
air racing, 28, 62–68, 172
air traffic controllers, 224
aircraft carriers, 98, 100, 238
aircraft spotter, 94
airports, 86, 258
airships, 8, 78–80, 118
Aldrin, Buzz, 186
Allen, Bryan, 220
ambrotype, 4
American Airlines, 86
Apollo 8, 184
Apollo 11, 186–190
Apollo 17, 190, 264
Apollo-Soyuz Test Project, 214
Ariane, 252
Armstrong, Neil, 186

Arnold, Rudy, 148
around-the-world flights, 48, 222, 250
astronauts, 176–190, 212, 230, 232
autogiros, 046

balloons, 4, 22, 212, 250
barnstorming, 50
Battle of Britain, 94–96
Bell 47D-1, 168
Bell Laboratories, 192
Bell OH-58D Kiowa, 256
Bell UH-1, 200
Bell X-1 (XS-1) *Glamorous Glennis*, 128
Bendix Trophy, 66
Benner, Harry, 20
Berlin Airlift, 130–132
Blériot XI, 24, 26, 34
Blériot, Louis, 24
Boeing 307 Stratoliner, 84
Boeing 367-80, 260
Boeing 707, 170
Boeing 747, 194, 228
Boeing 747SP *Clipper Constitution,* 194
Boeing 777-300ER, 260

Boeing B-17 Flying Fortress, 112, 114
Boeing B-29 Superfortress *Enola Gay*, 124
Boeing B-52 Stratofortress, 162, 198, 246
Boeing KC-135, 240
Boeing YB-52, 162
Braniff Airways, 170, 206
Breitling Orbiter 3, 250
British Airways, 208
bush pilots, 74

Cape Kennedy, Fl., 150
China Clipper, 82
Claudy, Carl H., 18
cockpits, 042, 246
Concorde, 208
Consolidated B-24 Liberator, 110
cosmonauts, 174, 214
crop dusting, 146
Cunningham, Randy, 202
Curtiss JN-4 Jenny, 50
Curtiss *June Bug,* 20
Curtiss NC-4, 44
Curtiss, Glenn, 20
cyanotype, 12

Daedalus, 2
Dayton Wright DH-4, 52, 54
de Havilland D.H. 106 Comet, 140
de Havilland D.H. 108 Swallow, 140
Deperdussin, 28
Dewell, Nathaniel, 52, 54
Doolittle Raid, 98
Doolittle, James H. "Jimmy," 64, 98
Double Eagle II, 218
Douglas B-26, 154
Douglas C-47, 130
Douglas C-54 Skymaster, 132, 142
Douglas DC-3, 86, 130
Douglas DC-6, 138
Douglas DC-8 *Flying Colors,* 206
Douglas DST *Flagship Massachusetts,* 86
Douglas World Cruisers, 48

Earhart, Amelia, 70
Earth, 184, 264
Edwards Air Force Base, Calif., 148, 166
Eighth Air Force, 102, 104
Enola Gay, 124
Erickson, Harry A. "Jimmy," 58
European Space Agency, 252

flight attendants, 138, 196
floatplanes, 62, 74, 134
flying boats, 44, 46, 82
Flying Tiger Line, 142

Ford Tri-Motor, 76
Fort Myer, Va., 18

Gabreski, Francis S., 104
Gagarin, Yuri, 174
Garriott, Owen, 212
Gemini IV, 182
General Dynamics F-16 Fighting Falcon, 248
Glenn, John H., Jr., 178–180
gliders, 6, 10, 72
Goddard, Robert, 60
Goodlin, Chalmers "Slick," 128
Gossamer Condor, 220
Graf Zeppelin, 78
Gray Rocks Air Service, 134
Groenhoff, Hans, 72, 134
Grumman F-14 Tomcat, 238
Grumman F4F Wildcat, 100
Gulf War, 242

Halberstadt CL.IV, 40
Hawker Hurricane, 96
helicopters, 90, 160, 168, 200, 256
Hindenburg, 80
Honeywell, Eugene H., 22
Hopson, "Wild Bill," 56
Hubble Space Telescope, 234
human-powered aircraft, 220
Hunter, F. K. Middleton, 80

Icarus, 2
Ingle, Gladys, 50
International Space Station, 254
Iraq War, 256

Johnson, Clarence L. "Kelly," 240
Junkers Ju 52/3m, 116
Junkers Ju 88, 126

Kellett KD-1B, 92
Kennedy Space Center, Fl., 226
Kitty Hawk, N.C., 10
Knight, Jack, 56
Korean War, 152–160
Kubasov, Valeri, 214

Langley Aerodrome No. 5, 10
Langley, Samuel P., 12
Le Jaune, 8
Lebaudy I, 8
LeMay, Curtis E., 162
Leonov, Aleksei, 214
Lester, Clarence "Lucky," 108
Lilienthal, Otto, 6
Lindbergh, Charles, 58
Livingston, Johnny, 66
Lockheed 10E Electra, 70
Lockheed 5B Vega, 74
Lockheed Aircraft, 30
Lockheed F-1, 30
Lockheed F-117 Nighthawk, 242

Lockheed P-38 Lightning, 122
Lockheed SR-71 Blackbird, 240
Lockheed Super Constellation, 136
Loughead brothers, 30
Lousma, Jack, 212
Luke, Frank, Jr., 38

MacCready, Paul, 220
Manned Maneuvering Unit, 232
Mars, 216
Martin M-130, 82
McCandless, Bruce, 232
McDivitt, James A., 182
McDonnell F-4 Phantom II, 202, 204
Meacham Field, Fort Worth, Tex., 86
mechanics, 54, 114, 156
Mercury *Freedom 7,* 176
Mercury *Friendship 7,* 178–180
Messerschmitt Me 262 Schwalbe, 122
MiG Alley, 158
Mikoyan-Gurevich MiG-15, 156
Miller, John M., 92
Mir, 236
missiles, 120, 150
Mobile Quarantine Facility, 188
Monocoupe 110 Special, 66
Moon, 184, 186

National Air Races, 66
Naval Aircraft Factory, 32

Navy Curtiss flying boats, 44
Nieuport 11, 36
94th Aero Squadron, 42
Nixon, Richard, 188
Noorduyn Norseman V, 134
North American B-25 Mitchell, 98
North American F-86 Sabre, 152
North American P-51 Mustang, 102, 108
North American X-15, 164–166
Northrop, John K. "Jack," 30
Northrop-Grumman B-2 Spirit, 244

Operation Desert Storm, 242
Operation Iraqi Freedom, 256

Pacific Alaska Airways, 74
Pan American Airways, 82–84, 194
Parker JP001 *Wild Turkey,* 172
Piccard, Bertrand, 250
Piper PA-25 Pawnee, 146
Pitts S-1C Special *Little Stinker,* 144
Ploesti, Romania, 110
Post, Wiley, 88
pressure suit, 88
Prosch PR-2 *Pole Cat,* 172

Quimby, Harriet, 26

Rash, Richard, 158
Reno National Championship Air Races, 172
Republic EF-84G Thunderjet, 148

Republic P-47 Thunderbolt, 104, 106
Rickenbacker, Capt. Eddie, 42
Ride, Sally, 230
rockets, 60, 152, 190, 252
Royal Air Force, 94–96
Royal Flying Corps, 34
Ryan NYP *Spirit of St. Louis,* 58

sailplanes, 72
Santos-Dumont 14bis, 14
Santos-Dumont, Alberto, 14
satellites, 192
Saturn V, 190
Schneider Trophy, 62
Shepard, Alan B., Jr., 176
Shuttle Carrier Aircraft, 228
Sikorsky HRS-1 (S-55), 160
Sikorsky VS-300, 90
Sikorsky, Igor, 90
Skelton, Betty, 144
Skylab Orbital Workshop, 210–212
Space Shuttle *Atlantis,* 236
Space Shuttle *Columbia,* 226
Space Shuttle *Discovery,* 234
Space Shuttle *Endeavor,* 228
Space Shuttle, 226–236
space stations, 210–212, 236, 254
spacewalk, 182
SPAD, 38, 42

Spirit of St. Louis, 58
stealth aircraft, 240–244
Steiner, John, 4
Steven F. Udvar-Hazy Center, Va., 260
stewardesses, 138, 196
submarines, 118
Supermarine S.6B, 62

Telstar, 192
332nd Fighter Group, 108
Titan II, 150
Trans World Airlines, 136
transatlantic flights, 44, 58, 218
Transcontinental and Western Air, 76
Turner Meteor, 68

Turner, Roscoe, 68
Tuskegee Airmen, 108, 154
TWA, 76, 136

U.S. Air Mail Service, 52–56
U-858, 118
United Express, 258
USS *Hornet,* 98
USS *Kitty Hawk,* 238

V-2, 120, 150
Vidart, René, 28
Vietnam War, 198–208
Viking 2, 216
Voyager, 220

Washington Dulles International
 Airport, Va., 258
Watson's Whizzers, 122
Watson, S. F., 200
White, Edward H., II, 182
Women Airforce Service Pilots, 114
women war workers, 32
World War I, 32–42
World War II, 94–126
Wright 1902 glider, 10
Wright 1909 Military Flyer, 18
Wright brothers, 6, 10, 12, 16
Wright Type A, 16
Wright, Orville, 18

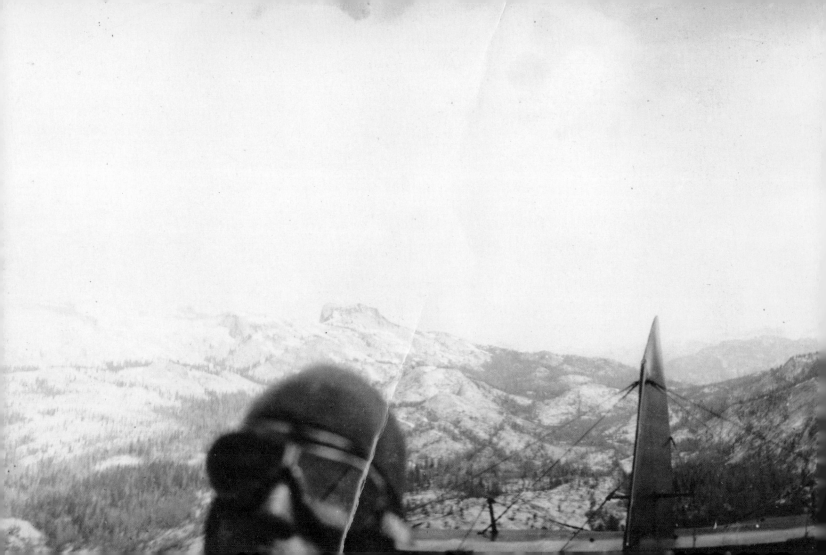